GRAFF

the art & technique of graffiti

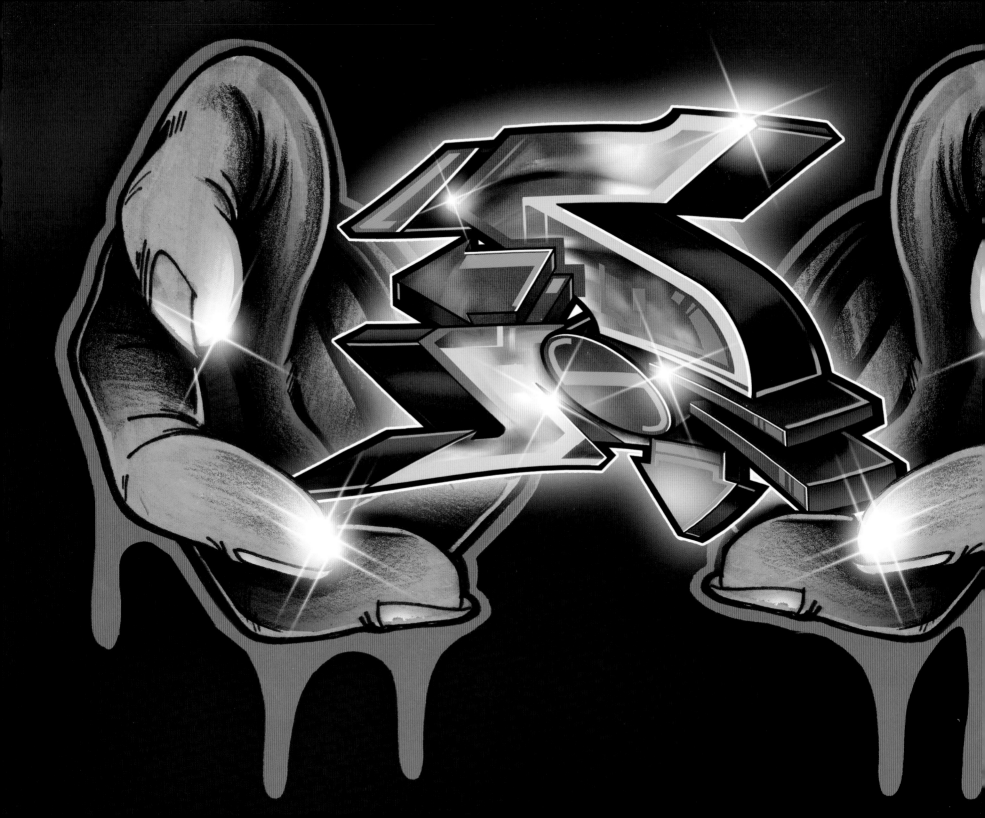

GRAFF
THE ART & TECHNIQUE OF GRAFFITI

scape martinez

IMPACT
CINCINNATI, OHIO
www.impact-books.com

Graff: The Art & Technique of Graffiti. Copyright © 2009 by Scape Martinez. Manufactured in China. All rights reserved. No part of this book may be reproduced in any form or by any electronic or mechanical means including information storage and retrieval systems without permission in writing from the publisher, except by a reviewer who may quote brief passages in a review. Published by IMPACT Books, an imprint of F+W Media, Inc., 4700 East Galbraith Road, Cincinnati, Ohio, 45236. (800) 289-0963. First Edition.

 Other fine IMPACT Books are available from your local bookstore, art supply store or online supplier. Visit our website at www.fwmedia.com.

16 15 9 8 7

DISTRIBUTED IN CANADA BY FRASER DIRECT
100 Armstrong Avenue
Georgetown, ON, Canada L7G 5S4
Tel: (905) 877-4411

DISTRIBUTED IN THE U.K. AND EUROPE BY DAVID & CHARLES
Brunel House, Newton Abbot, Devon, TQ12 4PU, England
Tel: (+44) 1626 323200, Fax: (+44) 1626 323319
Email: postmaster@davidandcharles.co.uk

DISTRIBUTED IN AUSTRALIA BY CAPRICORN LINK
P.O. Box 704, S. Windsor NSW, 2756 Australia
Tel: (02) 4577-3555

Library of Congress Cataloging in Publication Data
Martinez, Scape,
 Graff : the art & technique of graffiti / Scape Martinez.
 p. cm.
 Includes index.
 ISBN-13: 978-1-60061-071-4 (pb w/flaps : alk. paper)
 1. Mural painting and decoration--Technique. 2. Graffiti--Technique. I. Title. II. Title: Art & technique of graffiti.
 ND2550.M37 2009
 751.7'3--dc22 2008043364

Edited by Mona Michael
Designed by Wendy Dunning
Production coordinated by Matt Wagner

ABOUT THE AUTHOR

Born in Newark, New Jersey, and now living and working in San Jose, California, Scape Martinez has been creating art since childhood. Early in his teen years, he fell in love with graffiti art. He creates with spray enamel, house paint, markers, acrylic and watercolor. He owns and operates a street wear clothing line, Liquidscape Clothing, and is an arts advocate for kids. He has exhibited at the Movimiento de Arte y Cultura Latino Americana (MACLA) and has been assistant art director and lead artist-in-residence for the Children's Shelter of Santa Clara County, California. He's done murals for Stanford Law School, the East Palo Alto Mural Arts Project and San Jose City College. He has lectured on "Sights and Sounds of the Urban Environment," Arte Américas, Fresno, California; "Style Wars," Yerba Buena Center for the Arts, San Francisco; "Aesthetics of Graffiti," San Jose City College; and "History of Graffiti and Rap Music," Hayward State . He's shown at Punch Gallery, San Francisco; Berkeley Art Center; Cultural Initiatives Silicon Valley; Yerba Buena Center for the Arts; Art Museum of Los Gatos; Baldwin Hills Crenshaw Plaza, Los Angeles; and Works Gallery, San Jose. He has been featured in *Artweek*, *San Jose Mercury News*, *Metro: Silicon Valley's Weekly Newspaper*, *San Jose City Times* and *San Jose City College Times*. He is currently working in the area of public art with various cities on four-dimensional wraparaound murals that are graffiti-based. Visit his website at www.liquidscape.com and www.scapemartinez.com.

ACKNOWLEDGMENTS

Thanks to the staff at IMPACT Books. Thanks to Pam Wissman for starting me on this book writing process. Wendy Dunning for all the great design work and Mona Michael for keeping me focused and cutting through all the information I threw at her. You all treated me and my work with great dignity and integrity. A heartfelt thank you to The National Hispanic University for donating the wall space to execute the work. Thank you, Rosie Lopez, for your enthusiasm and prayers—you believed I could do it, even when I had my doubts.

NOTE: KEEP IT LEGAL

This book is meant to illuminate a worldwide art form, not to encourage illegal activity. You can practice your artwork and many of the exercises in this book in the comfort of your own home, using safe methods and good quality materials.

Images published here are meant purely as a record of paintings that have had a very limited lifespan and may no longer exist.

And always paint in legal areas; they are easy to find. Ask around, build relationships with store owners, for example. Search for out-of-the-way warehouses, unused tunnels, walls that are not in immediate public view, and then seek out the owners and get permission (in writing is best).

METRIC CONVERSION CHART		
To convert	**to**	**multiply by**
Inches	Centimeters	2.54
Centimeters	Inches	0.4
Feet	Centimeters	30.5
Centimeters	Feet	0.03
Yards	Meters	0.9
Meters	Yards	1.1

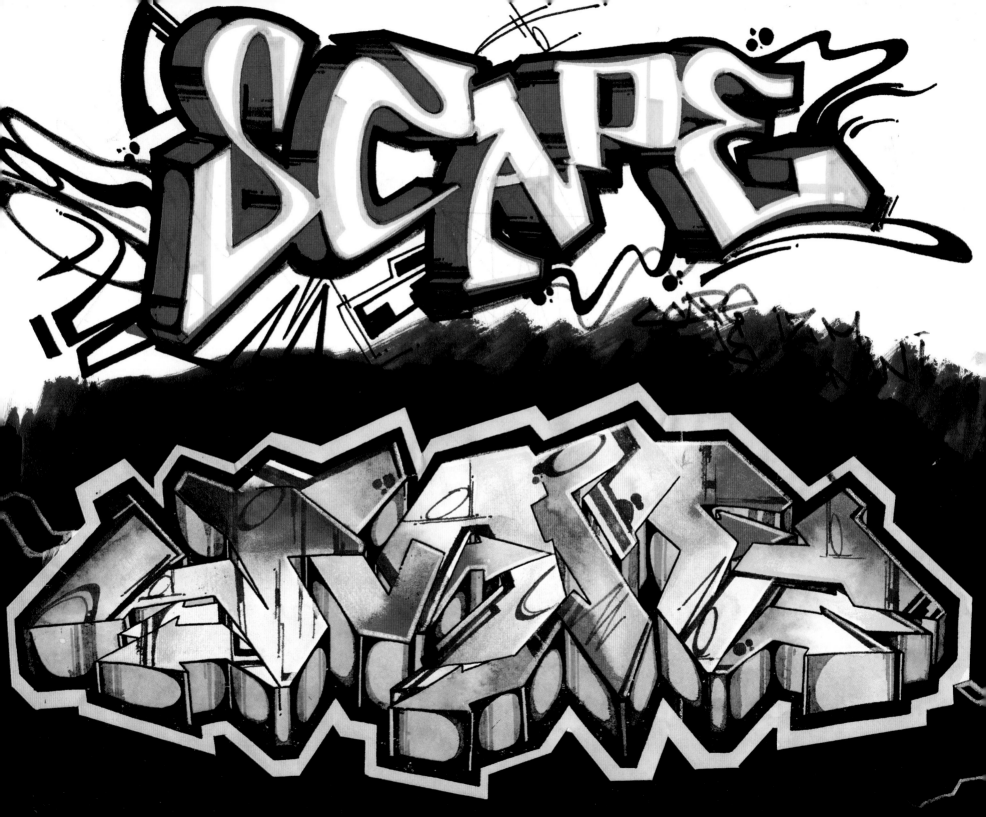

CONTENTS

1 THE ELEMENTS OF GRAFFITI STYLE 14

What Was Your **NAME** Again? * **TAGGING**: The Philosophy of the Line * Don't Be Afraid, **THEY'RE ONLY LETTERS** * Graffiti Letter Style **COMPONENTS** * **BUSTIN' OUT** Your Arrows * **3-D** Shapes and Shading Styles * Fill-Ins, Using **COLOR** * Graff **CHARACTERS** * Urban **ICONOGRAPHY** * **BACKGROUNDS**, Another Puzzle Piece * The **PIECE**

2 FROM SKETCH TO PIECE

A QUICK LESSON IN GRAFFITI HISTORY

The term *graffiti* originally referred to the inscriptions and markings found on the walls of ancient ruins, such as in the civilizations of Greece and Rome. Graffiti was done by the ancient Egyptians, the Vikings and even the Mayans. These people communicated with each other about daily life, currents events, etc., offering us a direct look into their ancient street life. It is a tradition of communication.

Even before this, there were caves in France where prehistoric man left markings on the walls to let us know who was there. And over the centuries, those caves evolved into the tunnels of the New York subway system, and today onto your computer desktop.

So you can go back in time and find that certain Renaissance artists explored the ideas of painting their names on walls as forms of decoration. French soldiers carved their names on monuments during the Napoleonic Wars in the early 1800s. There are also many examples of graffiti occurring in American history. It is part of our timeless quest for self-identity and self-affirmation.

So, how did this markmaking end up where it is today? Those same stylized markings can be found on clothes, in graphic design and as a basis for fine art in galleries around the world. Even the word "graffiti" has evolved over time to include any type of markings inscribed onto any surface, what some regard as vandalism.

From the womb to the tomb, we as human beings have had the need to create and to mark our territory. We need to let the rest of the world know we are here. This is the true foundation for graff writing.

Modern History

The beginning of what we call modern graffiti was laid out in Philadelphia in the late 1960s. Two writers named CORNBREAD and COOL EARL are credited with the first early efforts. They gained a lot of attention from the Philadelphia press and the community by leaving their signatures everywhere. Then, somehow, for reasons unknown, this concept traveled from Philly to New York around 1971.

Soon after that migration, New York produced one of the first writers to get even more media attention—TAKI 183. After an interview with him was published, hundreds of kids began to write their names all over New York. This was the start of getting *fame*, when writers used their signatures to become heroes in their own communities.

As graffiti became more and more popular and more visible, writers created new styles and thought of new ways to write their names and make their tags unique. Writers created many new script and calligraphy styles and enhanced their tags with flourishes and symbols. Some symbols were strictly for visual impact while others had meaning, such as crowns, which writers used to proclaim themselves kings. They used arrows to show movement and underlining to show importance. Quotation marks and exclamation points became essential design elements. This time, let's say between 1969 and 1974, is referred to as the "pioneering era," when graffiti experienced a surge in styles and popularity. But it was still strictly tag-based.

The Emergence of the Piece

The next major development was scale. In addition to the growing complexity and creativity, tags grew larger as writers increased letter size and line thickness and outlined their work. This was the beginning of the *piece*, short for masterpiece.

CIRCA 13,500 B.C.
Cave paintings of bison, deer and horses are created in Lascaux, France.

It is difficult to be certain who did the first true piece, but it is commonly credited to SUPER KOOL 223. The thicker letters provided the opportunity for writers to further enhance the name and to color the interiors of the letters with patterns and designs.

Around 1974, writers like TRACY 168 and BLADE created works that had serious backgrounds, incorporating characters, scenery and other illustrations on subway cars. This formed the basis for the mural whole car, called the *burner*, which led to *top-to-bottoms*, works that span the entire height of a subway car, and the *end-to-end burner*, when the entire car is covered.

By the end of 1974, the foundations were laid, allowing styles to develop that departed from the tag-styled pieces. This was a turning point in graff history, when graffiti made the leap from tagging to style-driven pieces. Soon arrows, curls, connections and twists ran all through the letters. These additions became the basis for *semi-wildstyle* and unreadable *wildstyle* lettering.

Writers such as RIFF 170 took ideas from other writers and improved upon them, helping the competitive atmosphere, which is a necessary aspect of graffiti. Other writers, including FLINT 707 and CASE 2, made major contributions in the development of three-dimensional lettering by adding depth to the piece, which became the standard.

Graffiti Worldwide

The spread of graffiti worldwide happened during the '80s with the explosion of hip hop subculture. Fueled by music videos and films, images of New York street culture were channeled around the world. Almost overnight, everyone wanted to be a New York City B-boy. Modern graffiti is often seen as being mixed with hip-hop culture. However, let's be clear: Modern graffiti predates hip hop by at least a decade. Graff was here before hip hop, graff will be here after hip hop, and if it wasn't for graff, there would be no hip hop.

That said, hip hop and graff reached Europe together. European writers spent years studying letters, styles and New York street culture. They copied the early styles, then expanded upon them. Graffiti magazines documented early movements across Europe. And the printed media proved to be an additional catalyst for the expansion of graffiti art worldwide.

Also during the early 1980s, American writers began touring Europe via art galleries in cities such as Amsterdam, Barcelona and Stuttgart. There was one major difference: European writers were focused on painting walls, not trains, which led to different styles.

Europeans also wanted to paint in the birthplace of modern graffiti, so many Americans hosted them in what were called *Pilgrimages to Mecca*. American writers went to Europe to paint and European writers came to America to paint. By the late '80s the European graffiti scene was in full swing.

Graffiti: It's All About Style

Graffiti art is a uniquely American art form. Today, it is influencing the work of creative individuals worldwide in areas as diverse as graphic design, photography, advertising, illustration, fine art and even multimedia and technology.

Why are we attracted to graffiti? I believe that part of it has to do with what I call the *psychology of self-affirmation*. There is something inside us that wants to take up space and proclaim our existence. Graffiti has always been about rebellion, style and observation.

When you do your thing today, you will influence the people of tommorow, and the observations they create will influence the next generation after that. And the pursuit of styles becomes a never ending quest. We must all think about improving, about getting better, because history will be watching.

I believe everyone—taggers, bombers and piecers—needs to take his or her own style to the absolute limit, and then do it all over again. Moving forward, we are concerned with style.

CIRCA **2697** B.C.
Chinese philosopher Tien-Lcheu creates India ink as an ink for blacking out the raised surfaces of pictures and texts carved into stone.

Graff writers work on paper for two reasons: First, as an exercise, since the sketchbook is a holding place for ideas, a place to experiment, to jot down notes and to save ideas; and second, to save final concepts on good paper, such as a heavyweight watercolor paper, this is after your ideas have been fleshed out.

You need very little to get started. You want a blackbook, 8½" × 11" (22cm × 28cm) or larger, and a trusty set of pencils and permanent markers of various widths. Keep everything in a backpack. You will always be sketching and doodling, so you want your tools to be accessible and quick to use. Below are some other things to keep in mind.

Pencils

A softer pencil gives you a darker value; a harder pencil gives you a crisper line. Also, look into charcoal and graphite. Both provide rich and intense blacks, but are easy to smudge. Explore colored pencils too, keeping in mind that they tend not to blend well. Choose what works for you.

Pencil Sharpeners

I stay away from expensive electric pencil sharpeners. I prefer a sturdy metal, inexpensive sharpener — the handheld kind. Buy them by the bunch, with various opening sizes, and they will last forever.

Erasers

You can use two types: *vinyl* and *kneaded*. You can cut and shape a vinyl eraser into a chisel for erasing in a very detailed fashion. You can form a kneaded eraser into organic shapes to lighten and erase sections.

Blending Tools

My favorite blending tool is my finger, but it's messy and can leave fingerprints all over your drawings. You can find *blending stumps* at most art stores. These are tightly wound rolls of paper with a point on each end. You can also use fabric, paper towels or even makeup sponges for excellent results.

Blackbook

Blackbooks (also called drawing books or plain sketchbooks) traditionally are hardcovered and black. The cover protects your drawings and makes it easier to draw outside. Make sure that the paper is acid-free so it doesn't deteriorate. And make sure it fits in your backpack.

Paper

Art paper comes many sizes, colors and textures. Get a few different types and experiment. Smooth paper works better with fast drying inks; paper with a slight *tooth* (essentially, texture) works well with pencil shading as it holds the graphite. Again, make sure that the paper is acid-free. Try working on larger sized paper as well.

Markers

Watercolor markers are basic markers that you can find almost everywhere. Usually sold in sets, they are inexpensive and great to use. The drawback is they are water-soluble, and even when dry, they can smear when exposed to moisture. *Permanent ink pens* are the classic Sharpie or Magic marker. The color choices are limited, but they're great for practicing tags and outlining artwork and work well in with watercolor markers since they don't smudge. *Paint pens* contain actual paint. Some even have a little marble inside to shake the paint up. They're great to work with, but they have a heavy odor and can be messy.

Inks

You can buy inks in little jars in a variety of colors. Work with them using either a paintbrush or a quill pen. It adds another dimension to your work when you can add a wash or drips from India ink. Check with your local art store for suggestions.

Watercolor Paints

In conjunction with inks, I like to use concentrated watercolors that are fluid. Check with your art store. Watercolors are transparent. I use them for backgrounds and letterfills.

Paint Brushes

Choose soft brushes. These let your watercolors or inks flow onto the paper and you don't have to fight with the paint. Again, check with your local art store, as you can pick up a few of these really inexpensively (it's good to have a few). Buy various flats to lay down watercolor washes, and a few rounds to add details.

CIRCA 800 B.C.

Around this time, the Greek alphabet is developed.

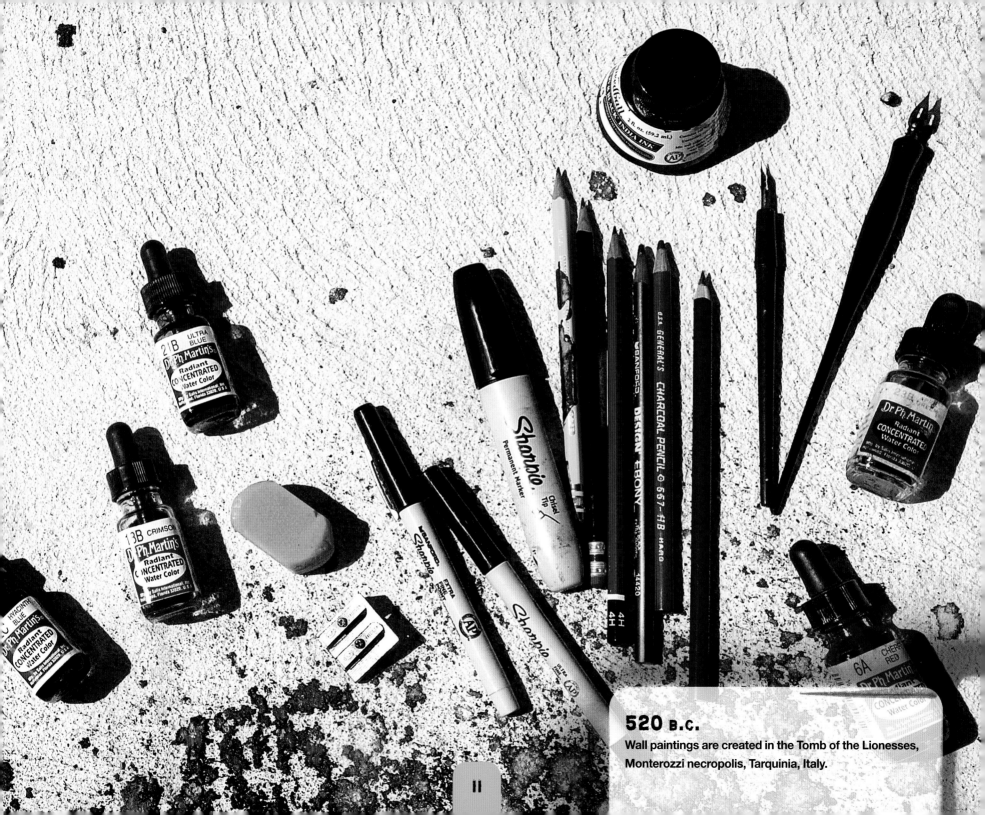

520 B.C.
Wall paintings are created in the Tomb of the Lionesses, Monterozzi necropolis, Tarquinia, Italy.

When choosing supplies, always go with the best quality you can get. Don't settle for less, as you'll regret it later.

Spray Paint

The equivalent of the artist's ink or paint, spray paint is the graff artist's most important tool. Different parts of the world manufacture paints to different standards, so experiment to make sure you make a good choice. You want paint that's bold, has a lot of color, sticks well to surfaces and covers surfaces well. Remember, the spray can is connected to the hand, and the hand is connected to the artist's heart, so I cannot overstress the importance of the quality of your paint. You will learn to express everything through the tip of the spray can.

Spray Can Tips

These are the equivalent of the artist's brushes. Now there are tons of caps out there, varying among the different types of paint. To start off with, just be aware of four basic types with some variations depending on where you are and what's available.

* fat caps
* skinny caps
* outline caps
* fill-in caps

Practice with these for sharpness, evenness, resiliency and calligraphic style. Pack plenty of caps, have more than you need, and take care of them.

Latex Gloves

Gloves protect the skin from paint. As you work your piece and change spray can tips, paint will begin to accumulate on your fingertips and hands. This can be problematic as it turns into a gooey mess, sometimes clogging tips and getting in the way. Also, depending on the type of paint, too much paint on exposed skin can be harmful down the road. It is best to play it safe. Bring a box of medical latex gloves and change them often.

Mask

To prevent inhaling fumes, use a legitimate gas mask—do not use a bandanna or dust mask! It may take a bit to get used to working with one, but it will protect you from fumes and overspray getting into your nose and mouth. Many a writer can talk poetically about how they never used to use masks back in the day. And many a writer can say they wish they would have. Play safe, play longer.

Health Tips

When executing your work, use common sense.

Follow any instructions to the detail on anything you use. Do not leave your spray paint in direct sunlight. Do not leave your spray paint in any area close to extreme heat or fire, heaters, etc. Take frequent breaks to rest your eyes, walk away, remove the gas mask and look at your work. Take a few deep breaths and continue your journey.

Discarding Materials

Do not leave anything at the site. If you must, bring extra bags to collect residuals: used latex gloves, broken or used spray can tips and, most importantly, empty spray cans. Even when you think they are empty, they are not. Over time, the paint will settle and someone will walk by, pick it up, and maybe choose to destroy your piece. Take everything you brought with you and dispose of all your used materials properly. From prep to completion, leave nothing. Leave the space better than you found it, your art included.

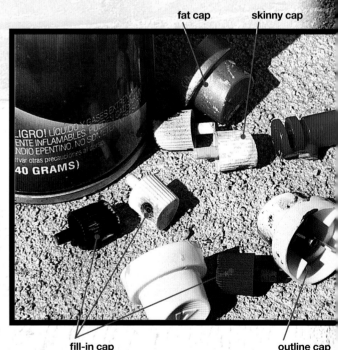

fat cap skinny cap

fill-in cap outline cap

CIRCA 220 B.C.

Mural is created in an Eastern Han tomb in Horinger, Inner Mongolia.

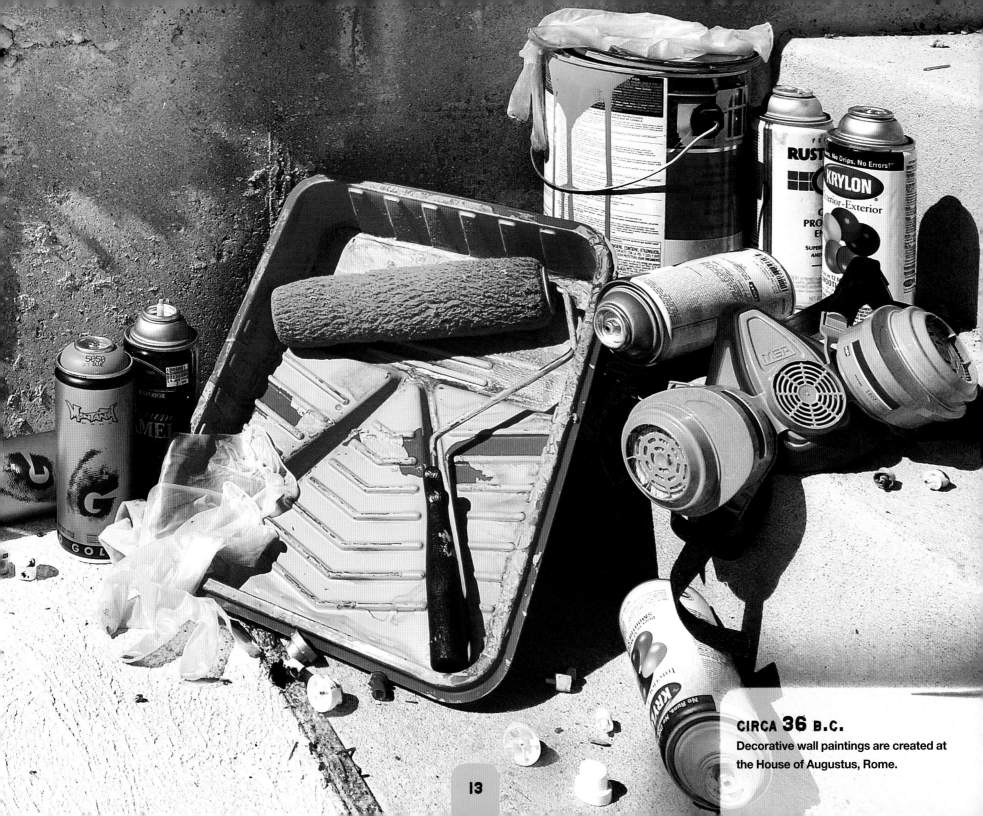

CIRCA 36 B.C.
Decorative wall paintings are created at
the House of Augustus, Rome.

13

14

THE ELEMENTS OF GRAFFITI STYLE

Graffiti writing has a style all its own. The elements that make up the building blocks of the art form, the nuts and bolts, can be isolated, picked apart and defined. Most, if not all, graffiti pieces will have these elements. They are the structure of the work, and they vary anywhere from the actual letter compositions to the color patterns used as fill-ins. They are the elements of graffiti style.

FOUR THINGS YOU NEED

In the end you need four pieces to make the whole, four quarters to make the dollar:

- **SKETCH**: The visible expression of your creative energy.
- **SPRAY PAINT**: The tool to manifest that energy.
- **WALL**: The vehicle, the battleground.
- **IMAGINATION**: This is your lifelong friend that you see only when painting. The invisible expression of your creative energy—hold onto him tightly.

CIRCA A.D. 79
Ancient graffiti with the monogram of Christ is inserted in the word "Beryllos," the name of Emperor Nero's secretary, on the walls of the Villa of Poppaea at Oplontis, outside Naples, Italy.

It's more than just your name. It's more than your tag. It's your identity; it's your brand. Your name is everything. In a sense, you are creating a brand identity for yourself.

I say more than your name because it's that important. It will be your form and your content. It's a visual manifestation of your alter ego; it's your main focus; it's your jumping-off point. No need to look for subject matter, no need to wonder "What am I going to paint?" Everything revolves around your name. Your name is your focal point. It will consume most of your art. It's your logo, your new you. This is where your artistry starts.

Choose Your Name Wisely

One of the first considerations when choosing a name is how it sounds. Where does the mind go when your name rolls off the tongue? What do you think of? Do you wonder, "What? What is that?" Names such as **DOZE**, **CRASH** and **REVOK** sound harsh to the ears and they can evoke certain images and feelings, or sound combative. Names such as **MAN ONE** and **KING 157** are short and to the point. That is a good thing.

How Does It Look When It's Written?

After going over your list of prospective names, write them out and see how they look. How do the letters work together? Do they flow? Is there a rhythm to the sounds and the look? Take the classic writer **SEEN**. A perfect name if there ever was one, **SEEN** is only four letters—short and action filled. The two Es in the middle are balanced by an S and an N. The two Es are great to write and are great letters to modify.

It is common practice to choose your name, then change or drop out some of the letters to make it work better when it is written. For example, take the name **SCAPE**. Originally, it was to be ESCAPE, but I dropped the E to make it shorter

and, since it's the first letter of my given name, I was "escaping" from that. Plus, I wanted to rock the S first; the letter S seemed more cool to begin a name with. The C and the A provided a great interaction. When developed, they actually create a visual tension in the letterforms.

Keep in mind all the mediums you will use when working with your name—pencils, pens, markers, spray paint and digital programs. A name can look splendid when done in cursive with a pencil and horrid when executed with the thickness of a wide chisel-tip marker.

Size Matters

Don't make your name too long. Ideally, your name should be short and to the point, evoke a sense of combativeness, sound a bit harsh to the ears and be clever whenever possible. **MERZ**, **EVOL**, **VYAL** and **SPIE** reflect this type of thinking. Your name needs to be written in a swift fashion so that your letters flow wherever they are placed. Also, when you begin to develop your name through various styles, you don't want to be burdened with the sheer complexities of the all letters in the name. Ideally, it should be no more then six letters in length. Think of successful names such as **SLICK**, **RISK** or **HEX**.

Look Into the Future

A special challenge is trying to peer into the future and envision your letters developed and how they may look together in a piece. When you're first starting, it can be difficult to know whether or not your letters will work in 3-D wildstyle, simply because you are not yet there stylistically. This is where an elder in the graff community can help. Many times an elder in the game will give you a name to work with, and over time, your mentor will modify it until you get a great name. An elder's experiences can steer you in a good direction.

CIRCA A.D. 300
Wall paintings are created in the tomb of Takehara, Fukuoka, Japan, Kofun period.

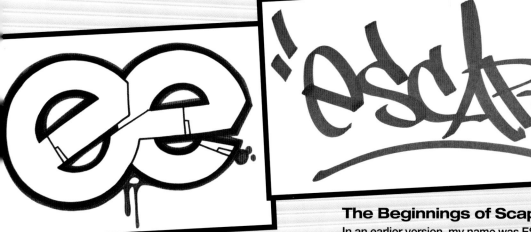

The Beginnings of Scape

In an earlier version, my name was ESCAPE. There was dramatic balance with the E on each end, but I dropped the first letter to shorten the name.

Double As and Es Promote Balance

These vowels promote balance and are fun to build up and add style to when placed together.

How Does That Sound?

I played with various spellings of the name. Here, I used a K instead of the C, but the K could be misread as an R.

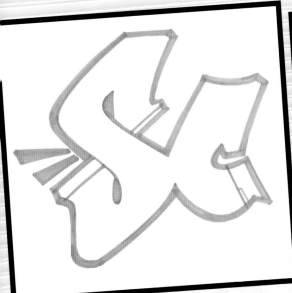

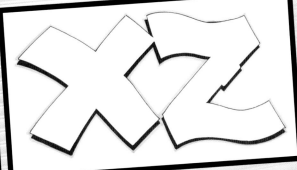

That May Not Vibe

Some letters are difficult to work with, such as X and Z. Individually, they are rough, but together the effect is worse. Other letters such as Q provide the same challenges, so be careful.

And The Winner Is ...

The combination of S and C works well. We recognize that the C is just the mirror image of the S with the top cut off, and this provides a great bridge and space to fill with color.

CIRCA A.D. 538

Wall paintings are created in the tomb of Muyong-ch'ong of Koguro, Korea, during the Three Kingdoms period.

What Does the Name Mean?

For some, the quick answer is that it means nothing. For others, we want more meaning. So, after all the thinking and sketching, we choose a set of names and letters and attach meaning to them. For example, "SCAPE ONE." S-C-A-P-E stands for Screaming Creative And Positive Energy. O-N-E means Obliterating Negative Energy.

Crew Names

A crew is a loose-knit bunch of guys who share styles, insights and a safe creative environment for their art. It isn't uncommon for a writer to be involved in one, two or even three crews. Let's be clear: A crew is an art thing. It is not a gang thing, and it is not a clique thing. Keep the spirit of creativity alive.
Here are examples of notable crew names:

TWS: Together With Style

CBS: Can't Be Stopped

CIA: Crazy Inside Artists

TUF: The Unknown Force

Can I Get Your Number?

In the early days, a writer's *number* (the set of numbers immediately following the name) represented the street he lived on. So, if I lived on 125th Street in New York, I would be **SCAPE 125**. Well, not everyone is from New York, and not everyone lives on a numbered street. So over time, the choice of numbers became a bit more subjective in nature. The number can be looked at as another design element or a way to be clever and creative. Names such as **MODE 2**, **ATE ONE**, **KASE 2**, and **A-I** reflect this thinking.

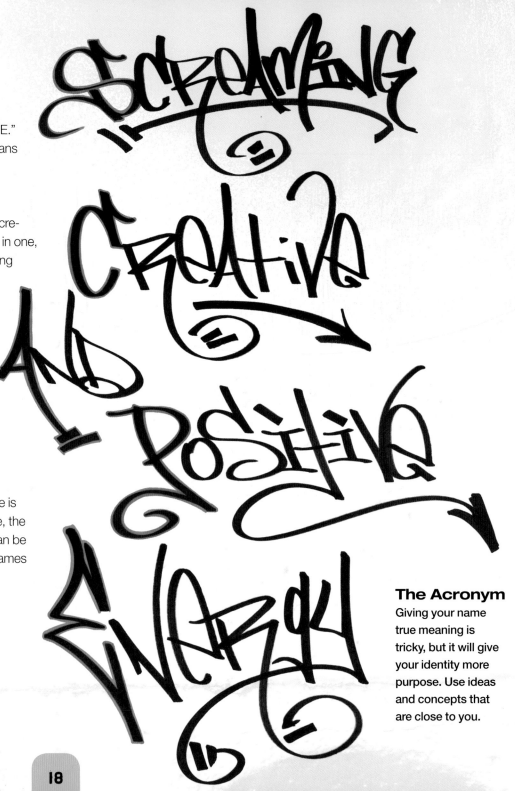

The Acronym

Giving your name true meaning is tricky, but it will give your identity more purpose. Use ideas and concepts that are close to you.

CIRCA A.D. 500

Wall paintings of Ajanta and Sigiriya are painted in water-colors on dry plaster on the walls of the carved-rock caves in India and Sri Lanka.

The word *calligraphy* comes from the Greek *kallos*, which means "beauty," and *graphe*, which means "writing." This is the beginning of urban calligraphy. One needs to approach it as beautiful writing. The first thing you need to understand is your line, and how your lines and marks can be expressive. The line can show movement and attitude.

Explore and pick up stylistic influences. Whether they are Asian, Indian, Persian or Arabic expressions, bring them all to the table. Think dynamically so your letters move or inspire you to move.

A tag and a name are the same thing. It is the artist's signature. And just like you would do a signature when you sign a check, you've got to know how to write it. Experiment with the tag until you feel comfortable. Vary your line thicknesses. Look for places to add hooks and barbs—arrows with sudden jumps in the line or the curves and undulations in a fishhook.

Find the comfort zone of your tag, where the marks don't supersede the legibility of the letters. You are executing something in two dimensions, so think linearly, not spatially. Visualize exactly what you want that line to say.

Elements of the Tag

Tags can be broken up into four basic elements.

* **Letter text**: the actual letters in the name

* **Arrows**: any kind of marks that point or provide a sense of direction

* **Flourishes**: added swirls, appendages or expressions building onto the letter structures

* **Symbols**: separate marks and expressions such as the king's crowns or hearts

Letter text

Arrows

Flourishes

Symbols

CIRCA A.D. 661

Arabic calligraphy flourishes throughout the Middle East as a spiritual technique and soon is recognized as the supreme art form of the Islamic world.

DON'T BE AFRAID, THEY'RE ONLY LETTERS

Letters are the most important aspect of graffiti writing, outside of the name. Moving forward, we have to remember that letters are symbols that over time (centuries), have developed meaning, sound connotations, etc. So proceed with this in mind: Letters are symbols that can be manipulated as you see fit.

Because letters so are important, a lot of attention and care needs to go into conceptualizing the letter patterns. But don't be afraid; I have some great ideas and samples for you to work from.

Imagine that your name is your brand and your letters are the vehicles of that brand. How would you put the brand into motion? How would you announce the brand? Letters are as infinite in style as we are as people, with all kinds of nuances, twists and differences. Just as people have unique personalities, so must your letters. Many people become overwhelmed by those differences, though, and get lost when creating their own.

Graffiti Styles

Before we get into the funky stuff, here are a few ideas. First off, familiarize yourself with the various styles of graffiti, not only worldwide, but locally as well. This is an area where graff has a special place in the art world; writers should make authentic visual connections with the community.

Distinctive styles have evolved that can be instantly recognized as graffiti, even when the writing is on a piece of paper. As with any art, there is no right way to draw graffiti, and you need to develop your own style.

Letter styles have developed into common categories. Here is a basic rundown.

* **Bubble letters**: Easily read and relatively easy to create, and the starting point for every writer.

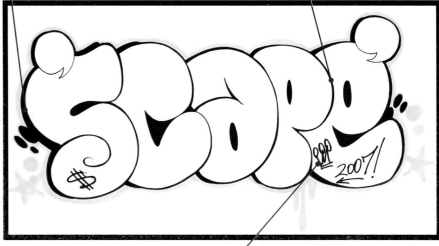

The basics use only three colors: Outline and shadow, fill, and glow.

Distinct circular motion— from the wrist on paper, and from the shoulder and waist on the wall.

Letters overlap, but are not connected.

Bubble Letters

All lowercase.

Since the letters are fat, you can add extra writing inside.

Symbols that are special to you.

CIRCA A.D. 700
The quill pen is introduced, made from bird feathers.

* **Block letters**: Sometimes called *straights*; they can have 3-D or not. They are slightly more difficult than bubbles because the lines need to be as straight as possible without rulers.

* **Semi-wildstyle**: Here is where the fun begins. These letters are semi-readable. Keeping them legible is a main focus. Here, you can stylize your letters up to a point and use arrows and connections to make the letters flow.

* **Wildstyle:** Legibility goes out the window; it's not important here. Here, the style and execution is important. Sometimes only those who know how can read it, namely experts of wildstyle, or individuals who know the artist.

* **3-D wildstyle**: The next level of wildstyle. The letters are broken up into distinct three-dimensional shapes. They lay on top of each other; they can curve into each other or begin to take architectural type qualities. A firm understanding of perspective is necessary.

* **Abstracts**: The pendulum swings the other way from 3-D wildstyle. The letter shapes take a slight back seat to the use of color. You want to explore color, and the patterns have value. Think of it as coloring outside the box.

Bits breaking off the glow.

Colors are basic: fills, outline and glow.

Legible and basic.

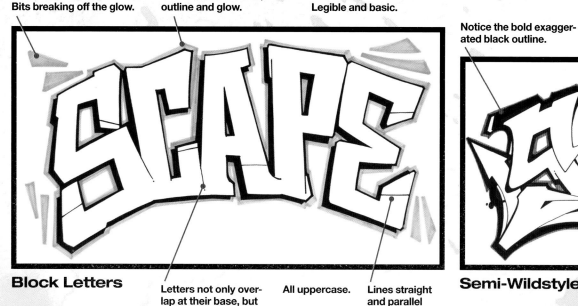

Block Letters

Letters not only overlap at their base, but also connect.

All uppercase.

Lines straight and parallel where needed.

Notice the bold exaggerated black outline.

Vary your line thickness all around the letters.

Only five arrows are used

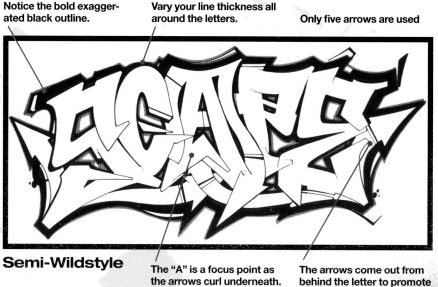

Semi-Wildstyle

The "A" is a focus point as the arrows curl underneath.

The arrows come out from behind the letter to promote balance.

CIRCA A.D. 776
Murals are painted in the Bonampak in the rainforests of Chiapas, Mexico.

Flat and with 3-D.

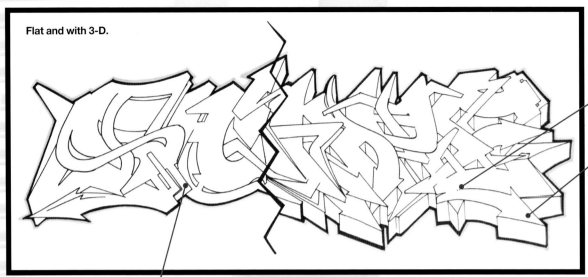

3-D can either add or take away from legibility.

A few dots for extra feel when arrows are attached to letters.

Tons of arrows climbing and curving all over the letters.

Wildstyle

Thin lines on the insides of letters.

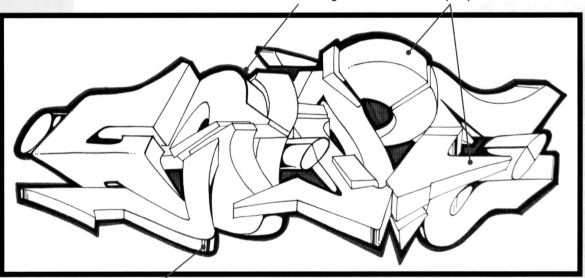

A solid glow around the entire piece ties the broken units together.

Multiple points of view and perspectives.

3-D Wildstyle

Darker values in certain areas of the 3-D adds punch.

ARROW TIP

Arrows can work alone or in conjunction with your flourishes. This means your flourishes can end with arrows and your flourishes can sprout from your letters, too!

CIRCA 1564

Around this time, an enormous deposit of graphite is discovered at the site of Seathwaite Fell near Borrowdale, England. The locals use the graphite for marking their sheep.

The traditional outline is erased in various sections. Where it's gone, both areas blend together.

The background colors and glow work their way into the letters.

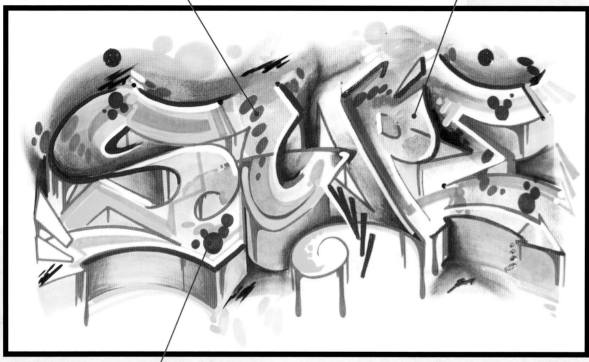

Abstracts

Black is used as a color and as an accent, not as an outline.

PRACTICE TIPS

* Draw lightly so that you can erase your lines.
* Use a permanent marker only after you are done sketching.
* Take your time and be meticulous with your lines.

1662

The first attempts to manufacture graphite sticks from powdered graphite occurs in Nuremberg, Germany.

These are some of the major components that you'll see worked into graff letters, symbols and shapes.

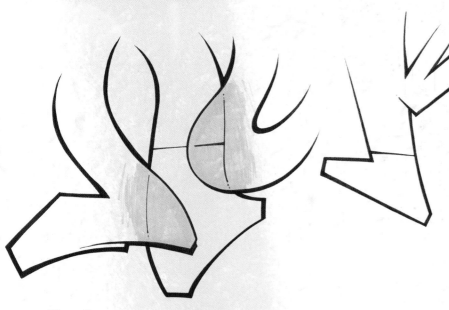

Overlaps
As indicated by the yellow shaded areas, overlaps can be made to appear transparent. Also, you can bring some of the drop shadow over the letter.

Extensions
Extensions are the simplest elements. An extension is when you stretch a regular portion of the letter out to where you want it. An extension differs from a flourish because a flourish isn't a necessary part of the letter, but an extension is.

Connections
Connections can overlap, go over, go under or pass through, but their purpose is just to connect two disparate letter pieces. These pieces add a level of complexity.

Flourishes
A flourish is a piece of mass that comes from the main letter body for decoration. A flourish can end with bits, and you can add arrows to their tips, or they can be pointed as you see here. Also, notice that the flourish begins from a serif.

1685
Andrea Pozzo, master Italian painter and stage designer, begins frescoes, most notably "The Entry of St. Ignatius Into Paradise" at the church of Sant'Ignazio di Loyola in Rome.

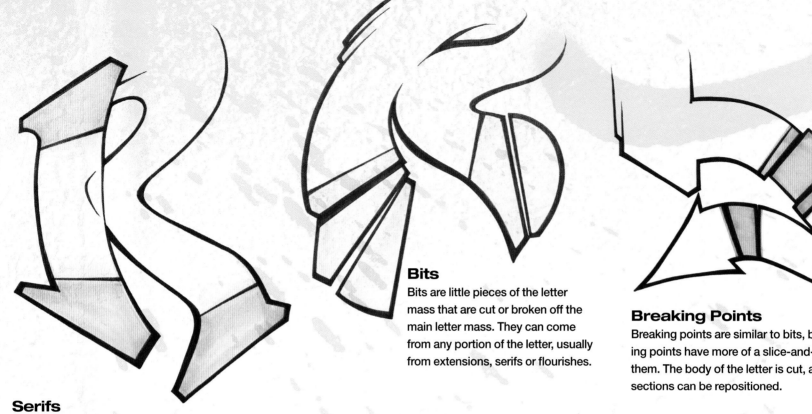

Bits

Bits are little pieces of the letter mass that are cut or broken off the main letter mass. They can come from any portion of the letter, usually from extensions, serifs or flourishes.

Breaking Points

Breaking points are similar to bits, but the breaking points have more of a slice-and-shift flavor to them. The body of the letter is cut, and the sliced sections can be repositioned.

Serifs

Serifs are the "feet" of your letters, just as in traditional type and fonts. But in graff, they are animated, and you can take a whole lot more liberties with their directions and shapes.

Computer Styles

Almost architectural in nature, these capture a certain rigidity and strength by their design. There are lots of parallel lines mixed in with sharp angles and a distinct pyramid type of theme. You can see the influence of circuitry and mechanical design.

1795

Nicholas Jacques Conté of France discovers a method of mixing powdered graphite with clay and forming the mix into rods. By altering the mix, the hardness of the graphite rod can be changed.

BUSTIN' OUT YOUR ARROWS

One of the most telltale style elements in graffiti art is arrows. They are meant to guide the eyes and steer the viewer to where you want to take him or her. Arrows also communicate energy. In simpler letters, make arrows thick and chunky, while in more complex letters, use thinner and more pointed arrows. Treat arrows like you would weapons in an imaginary arsenal: Keep them sharp and strong, and use them with purpose. Don't overuse them, though. Strategically mix them with other style elements to create your own unique mix and flow.

Practice your arrows again and again. Let them evolve. Make compositions consisting entirely of arrows, just so you understand their energy and how they can work together.

ARROW TIP

When doing arrows with a point, it's easier to draw them with slightly curved lines leading up to the point, rather than with straight lines.

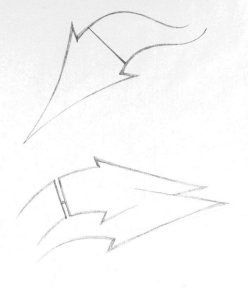
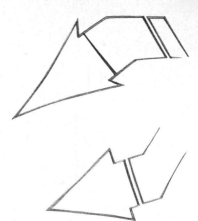
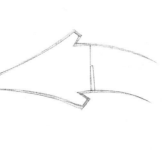
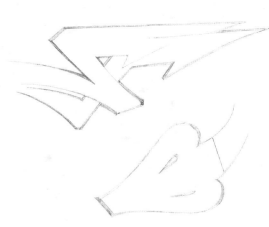

Arrows Come in All Shapes and Sizes

Arrows can be stylized in many different ways. Remember to keep them balanced; make sure the point of the arrow flows in the same direction as the letter you're using it with.

Arrow Manipulation

You can "double up" arrows to make them more complex. You can even try "tripling" them: Lay them on top of each other, have them peek from behind the letters, or break them into slices.

1812

The first American wood pencils were made by William Munroe, a cabinetmaker from Concord, Massachusetts.

3-D SHAPES AND SHADING STYLES

Here are a few basic graff-based 3-D shapes and shading styles. In these concepts, the curving outline of the forms is an organic shape. The writer can use different types of shading to highlight the form and show depth.

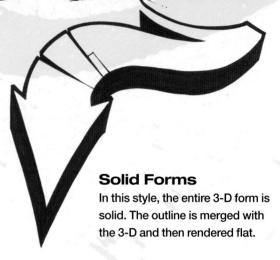

Solid Forms

In this style, the entire 3-D form is solid. The outline is merged with the 3-D and then rendered flat.

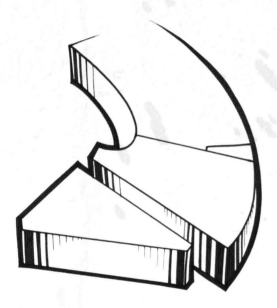

Traditional Shading

Choose a *point of reference* (starting point) and work from dark to light. So, if the dark areas are radiating from the center, keep it that way. Study where the light comes from so that it makes sense to the viewer.

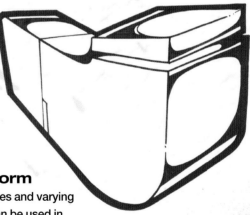

Shading by Decreasing Line Weight

There is no shading involved per se, because the shading is done by gradually decreasing the *weight* (thickness) of the lines. As the eye moves away from the edges of the form, the lines become narrower and shorter. The mind fills in the blanks, completing the illusion of depth.

Shading Based on Form

All the shading is done with curves and varying line thickness. This technique can be used in conjunction with the other styles.

1821

Julius Griffiths, an Englishman, was the first person to patent a passenger road locomotive.

27

FILL-INS, USING COLOR

All graffiti is based on color, even if it's only a black-and-white throw up. Vibrant colors produce great energy, action and excitement. This is crucial to effective composition in graffiti art. Color is the main reason that you stop and stare at a piece. And this is because of contrast. Color patterns have to contrast.

One of the important differences between graff and traditional art is the palette. Since the primary medium is aerosol paint, the palette is limited. Tints and shades don't get much play because we use the paint right out of the can, without color mixing. And because of the variations in the physical locations we use as surfaces and the bold colors, we get a powerful, universal effect. You'll notice that when graff artists use traditional mediums, such as acrylic or oil paints, we tend to use them raw out the can, tube or jar.

There are an endless variety of color types and color patterns. You can go with solid colors, then add dots and spheres on the inside, or you can go all out with multiple colors.

There are three basic types of fill-ins: camouflage, fades and cut and slice.

Camouflage
Camouflage uses four or five colors that are organically shaped and arranged. Colors are massed together and lightly blended.

Fades
Fades are a minimum of three colors; they can be both directional and nondirectional. A lot of movement can be created. The colors that lie on top are blended in a wispy, almost whimsical, and atmospheric fashion.

Cut and Slice
The most important issue here is technique. First, the colors blend and are faded together, then a sharp edge is cut and sliced into each to generate tension. Colors can be treated as bars and graphs, computer motifs and geometric shapes.

1857
Frederick W. Redington and William H. Sanford, Jr. form the Sanford Manufacturing Company in Massachusetts, selling ink and glue. Later they will manufacture Sharpie markers.

GRAFF CHARACTERS

An easy way to understand graffiti-based characters is by looking at them under the lens of *Urban Cartooning*. That means the point of view of your characters should be urban, edgy and raw. The dynamics that can be part of your letters can be part of your characters as well.

Characters can be as varied as your letters; after all, they represent us. They should be bursting with energy. They should leap off the wall and the pages of your sketchbook. Use inflated outlines, intense colors, high contrasts and distorted perspectives. Develop your characters to be bold, exaggerated and full of movement. But most of all, they should have character.

Keeping It Real, Or Unreal In Our Case

Graff characters won't be found in the comics section of your local newspaper. They have an element of satire. It's almost unspoken, but it's always there. Graff characters stand for something and don't shy away from political or social commentary. Even a classic B-boy standing defiantly with a spray can in hand makes a statement.

We don't want to re-create the world exactly as is. For that we have cameras. We want to re-interpret the world in our own fashion. So don't be concerned about anatomical correctness. The coloring and design of the characters needs to reflect their character. Feel free to borrow from mainstream images of cartoons and other subject matter.

Ideas to Use for Character

Graff writers use several ideas to get their points across with their characters. Not every character includes all of these, but most include at least a few.

* **Irony:** The idea of how things are versus how they should be. A sense of humor can come into play here too.

* **Symbolism:** This is used when dressing up your characters to have specific meaning, such as a police officer, or creating your character to appear to be iconic, like the donkey or elephant in American politics.

* **Exaggeration:** This could be oversized sensors, meaning that their eyes, ears, hands and feet should be larger. Eyes are expressive and hands are animated.

ANTHROPOMORPHISM, GHETTO STYLE

To really acquire a sense of composition and balance, merge your character with your letters so that they are one unit. Give your character qualities from your letters and your letters qualities from your character.

1858

Hymen Lipman receives the first patent for attaching an eraser to the end of a pencil. Now all would-be artists don't need to be afraid of making mistakes.

Once you learn to spot these ideas, you'll be able to see the writers' points more clearly and notice how the characters tie in with the letterforms and color choices.

Keep the spirit of satire flowing. We don't want to make mirror images of society; we want to poke fun at it, to distort it. One way is to change the perspective of the piece or change the plane that the character sits on.

Real vs. Abstract

You can stylize your characters over and over and over. Adding details on top of details and color on top of color. You may decide to break them up into pieces or sections. You may even get to the point where you begin to deconstruct them and find yourself in abstract territory. And this is OK.

Take a look at these images and notice the differences between "real" characters and "abstract" characters.

Basic Graff Character With Ball Cap

This image is kept simple with bold outlines and lots of shadow. The use of black is prominent to set a mood, while arrows and dots are added to the purple glow. If you know that you are going to do a character on a wall, you want to keep it simple.

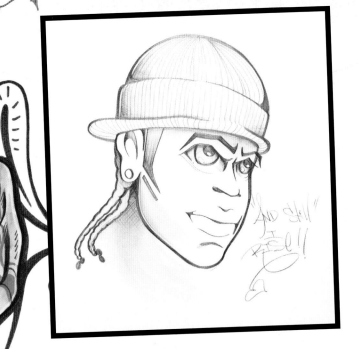

Bandana

The bandana around the face is a common look. But the focus really is the red swirls coming out of the glow. Take the flow, the movement from the outline, and push outward into the blank space with it to make your image stand out even more with bold visual information.

Pencil Rendering ¾-View

Always pair up your characters with a statement. Whether or not you actually use it as a quote, it will help give a direction for the work. Here, the eyebrows are solid and angular, and the sideburns are absolutely perfect, as if chiseled onto the face. Notice how the fade in the sideburns is going in the opposite or "unnatural" direction.

1866

Henry Sherwin and Edward Williams found the Sherwin-Williams Company, which becomes the parent company for Krylon spray paint.

Deconstructing Your Characters

You can simplify your characters by flattening out the images. Removing the face gives anonymity and mystery. "What's going on here?" Focus less on physical details and more on energy. Add shadows, random expressions and swirls to your composition.

Wild Expression

Wildly expressive eyes pair up with equally expressive hands and fingers. Find great poses and positions for your characters' facial expressions and hands. The hands are floating in space, giving us an excuse to place them wherever we want.

Abstract

Here, I started from a background and worked forward. I took parts of the image that would normally be 3-D (like the face and hat) and made them flat, then took what would be flat (like the background) and made it more 3-D.

A QUICK COMMENT

Yes your character can be a "symbol" and yes your character can take the place of a letter in a piece.

1870

Joseph Dixon develops a way to mass produce pencils and manufactures the first wood and graphite pencils in America. The Joseph Dixon Crucible Company later becomes the Dixon Ticonderoga pencil and art supplies company, the world's largest dealer of graphite.

URBAN ICONOGRAPHY

The use of symbols in modern graffiti has progressed to the point that symbols can play a prominent role in a piece. Sometimes a symbol can take the place of a letter. In fact, letters *are* symbols, so symbols can be letters, too. Symbols add an immediate level of depth and a frame of reference to your work. Graffiti as a whole is a unique set of individuals working in their own personal set of symbology. Whether they are letters, objects, glyphs or characters, symbols play a role in your work.

Just like letters, symbols can be developed into 3-D objects or can take the shapes and forms of scripts and expressions. The most basic symbols are dots, drips and exclamation points. They can be spontaneous expressions of abstract thoughts or thought-out design elements. Other symbols can take the forms of characters or miniature illustrations, or even bits from other objects.

But they must represent something. Many symbols have immediate cultural, historical and artistic values. Research religious or spiritual symbols before using them if you aren't intimately familiar with them. Not only would it be foolish to use something that you don't understand, but also you might find that the symbols represent beliefs that are contrary to your own. So whether it's Masonic, Aztec, Chinese, or Greek, do some research and explore.

Expressive Symbols
Swirls, stars and expressive lines add tension and more visual information.

Arrow
This early type of graff symbol provides a sense of urgency and direction to a tag or piece.

Crown
Indicates that someone is claiming the title of king, the best at a particular style or the most prolific.

Heart
Popular classic symbol seen frequently in tags and throw ups. It has transcended the classic meanings of love and affection.

1879
The first airbrush was invented by Abner Peeler, in Iowa. White T-shirts will never be the same.

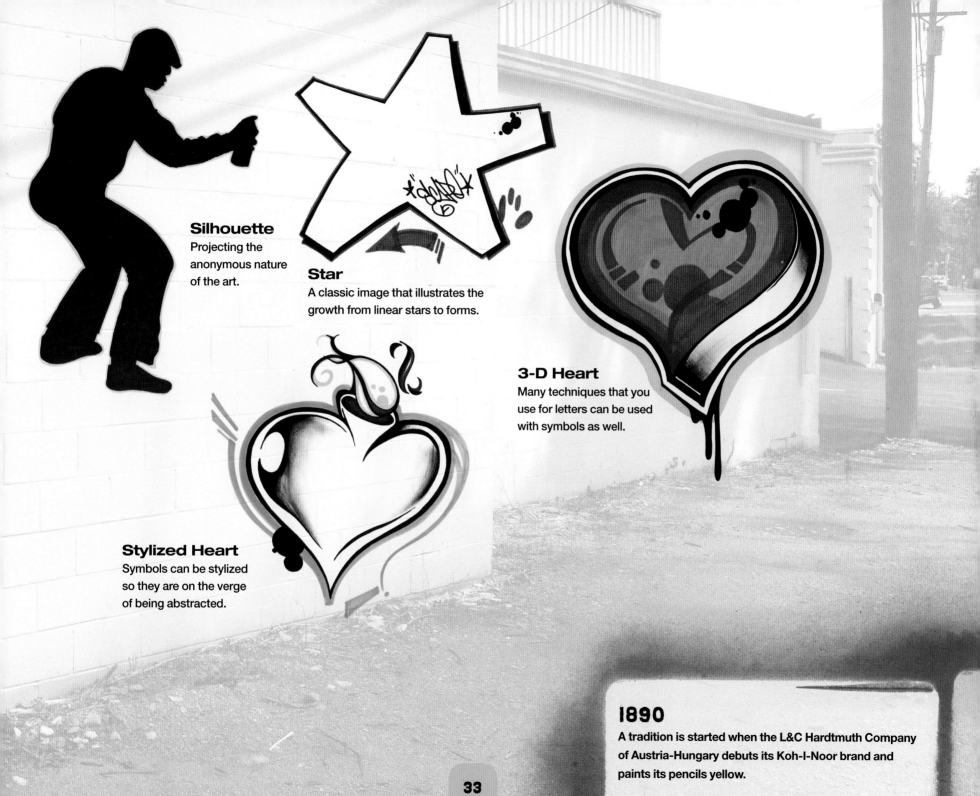

Silhouette
Projecting the anonymous nature of the art.

Star
A classic image that illustrates the growth from linear stars to forms.

3-D Heart
Many techniques that you use for letters can be used with symbols as well.

Stylized Heart
Symbols can be stylized so they are on the verge of being abstracted.

1890
A tradition is started when the L&C Hardtmuth Company of Austria-Hungary debuts its Koh-I-Noor brand and paints its pencils yellow.

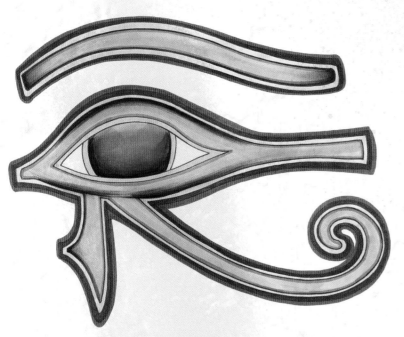

Eye of Horus

A symbol of power that shows up a lot in graff. A carry-over from hieroglyphics, it echoes that tradition.

Ankh

A symbol of fertility. Graff artists recognize their role in a centuries old tradition.

Stylized Spray Can

This symbol shows the allegiance of the artist to the movement.

Scroll

The scroll automatically provides an avenue for additional commentary from the artist.

1893

The first modern type of airbrush was invented by Charles Burdick and presented by the Thayer & Chandler art materials company.

Replace a Central Letter

Here I used a set of dice to replace the A. When using symbols as letters, remember to replace a central letter so that the word will be understood as well as the symbol. Balance the content on the left and on the right when replacing letters; otherwise you could send viewers in the wrong direction.

Replacing a Letter With a Symbol Creates a Statement

Here, I took a basic semi-wildstyle "Scape" piece and replaced the letter A with the tip of a spray can. It's a little part of the code. It's not two words separated, it's one body, one statement.

1904

The first IRT subway line opens.

The background can make or break a piece. There are as many ways to do a background as there are to do letters and characters. The trick is knowing in which direction to go and where to stop. In some cases, you can even leave your background blank or *raw*, but if you really want to know the power of graff, you must understand the role of backgrounds.

Concrete vs. Abstract

There are two broad avenues for the backgrounds in graffiti. Their differences are clear, but they have the same purpose. The objective is to prop up the piece to give the letters the proper surroundings, allowing them to pop. You want to communicate a sense of space, where the letters can occupy that space and say what needs to be said at that time.

A concrete background is a background that is based on real, tangible scenarios, such as a cityscape or some kind of scenery. An abstract background is based solely on color without tangible objects.

You'll also have to choose whether you want colors that compliment or contrast your letters. A popular question is "Can you mix them together?" Of course you can, but don't get too complex when you start out. Keep it simple at first, and then build up to more complex images and patterns.

Bricks

This is the classic background. The purpose is to bring some of the urban chic into a piece. Keep the bricks symmetrical and equally spaced. Use shades of gray or earth tones for the bricks so your letters will stand out. Add cracks for an aged feel. Additional shading and highlights help bring the bricks out.

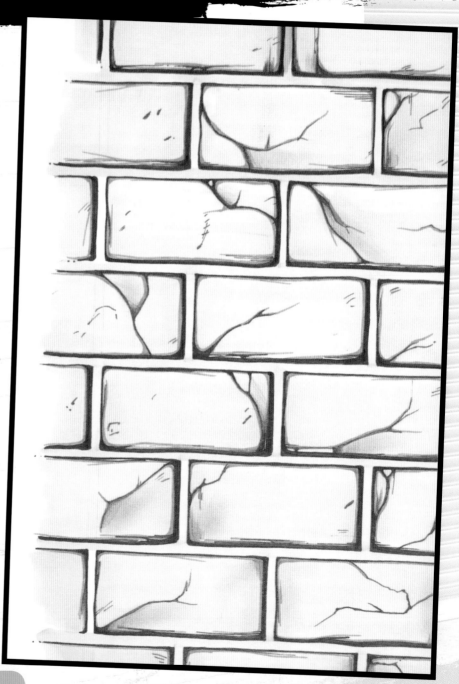

1921

Spray paint company Rust-Oleum is founded by Robert Fergusson, now owned by RPM International, Inc.

Classic Material

The following examples are some popular ways to portray your backgrounds. Don't limit yourself to just these; explore and experiment and learn new ways to create your own backgrounds.

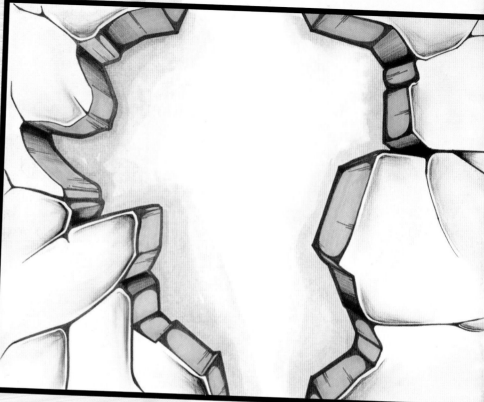

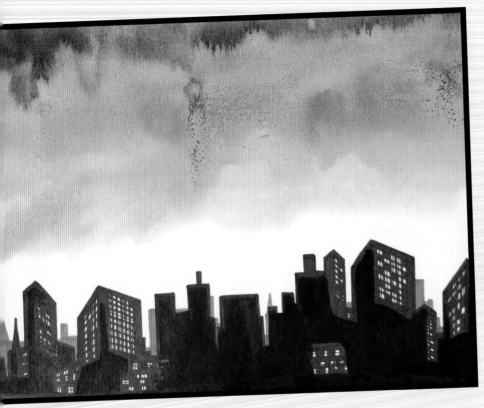

Breakthrough

The objective with this background is to show your letters "breaking through" the walls—a very symbolic relationship between the writer and the world at large. Breaking down walls and crushing through opposition is the theme. Keep the solid matter in shades of gray and earth tones. The 3-D is blue to contrast with the yellow.

Skyline

Another classic background, and relatively simple to do, is a panoramic view of your town or city. Creating a second layer of buildings (the orange ones peeking out from behind the black) adds a sense of perspective and depth to the skyline. Keep the central structures solid black and add lights to the ones on the left and right to create visual information to interest the viewer. Using multiple perspectives within the background (the solid black is flat and straight ahead, while the lit buildings are from a worm's-eye view) adds interest, too. Control the mood with the color of the sky; the reds and oranges here set a somber mood. Lastly, the sky and the buildings create two planes; your letters introduce a third. Keep that in mind.

1925

Sakura invents a new drawing material, which combines oil and pigment. Cray-pas, the first oil pastel, is introduced to the world.

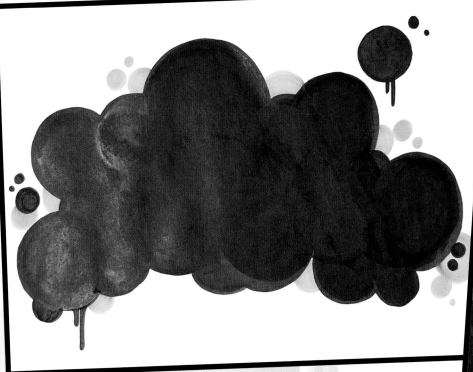

Clouds

This background is often found in traditional street-level graffiti and graphic design. Here the first level of clouds is black, and the second layer is blue. This is the basic idea for overlapping shapes. It's basically a series of ovals and circles laid over each other, again and again. From this point, you can further enhance the clouds with another outline or a glow.

Pattern

This background is based on the idea of taking space. The types of shapes and shading is very similar to the types of color patterns that you can use inside the letters. For the background pattern, it is very important that you do not replicate the patterns from the inside of the letters to the background. This type of background is flat and does not work for creating depth perception.

1927

Erik Rotheim, a chemical engineer from Norway, invents the first aerosol spray can.

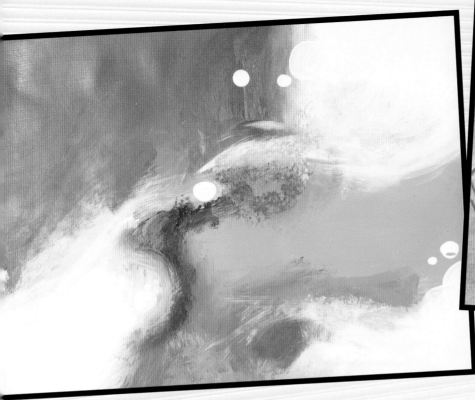

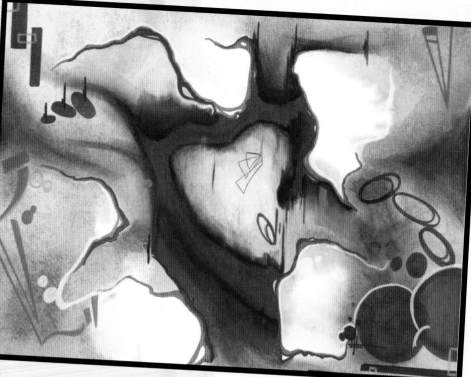

Color Field

The sense of depth for this background comes from the *atmospheric perspective* (color intensity, size and texture details lessen as they recede in space). Use two or three tonal or color values (each represents a plane) and fade them together. The background is hazy and faded to contrast with the bold tightness of the letters, which would be in the foreground. In this type of background, you want to create a sense of distance and space. Here, I also added a few dots coming out from the white. Remember, in graffiti art, white and black are treated as actual colors, not just as accents or highlights.

Abstract

It is well advised that you get the hang of the basic ideas of background before getting into this area. But when you do get to this level, it's a great tool to have. This relatively simple background contains multiple sources of light and multiple focal points. Black is treated as a color. There is controlled color fading and whimsical elements with pink highlights. Also, there is a conscious effort to create visual tension that will play along with your letters.

It is imperative to know how to handle your letters here because your background energy can overtake the power of your letters.

1933

Henry Levinson establishes the Permanent Pigments Company, a small enterprise that makes artists' oil paint.

THE PIECE

Piece is short for masterpiece. It's the last stop on the graff train. It is the result of all your efforts: your letters, characters and backgrounds all working together and intermingling with symbols, quotes, and tags (yours only, of course). It is your total composition, the sum of all the parts, and you hope that the sum is greater than the individual components.

Pieces are big, bold, wondrous works of art. They are labor intensive to execute and to visualize and sketch out. Your letters and composition need to be fully developed and thought out. Have full-blown 3-D and multiple arrows; keep your color transitions tight; use other effects and details. The piece should have rich, robust characteristics, with symbols and characters and statements and quotes.

What Makes a Piece "Good" or "Bad"

Ideally, a piece is the sum of three components: the character, the letters and the background. These components can be viewed as layers, with each layer possessing its own characteristics. It's the artist's job to bring them together.

Each layer is in its own plane and, whenever possible, should be in its own unique perspective. Working with multiple perspectives makes your pieces visually interesting. Try to get perspectives that other writers may not have tried or that you have not often seen.

If You Have to Choose, The Letters Win

It's possible to have a fantastically executed character with weak letters. And that's bad. You don't want one element claiming ownership of the entire piece, unless that one element is the letters. If the other elements are not up to par, consider revising or omitting them. In this instance, simpler is better. And if you're not up to speed in your styles, don't try and be too complex.

Also, pay attention to your execution. Are the lines straight where they need to be? Are the curves smooth and flowing, or broken and crooked? Drips are a negative, unless you paint them yourself. Drawing skills and a knowledge and sense of scale plays out here.

What to Look for and Create in a Piece

* **Creativity:** Is the piece visually interesting? Is it letting you see things in a new way? Is it telling the whole story or parts of it? Do the characters show expressions? Do the colors convey moods? Do the letters show movements?

* **Consistency:** Is the style consistent? If you start your letters out in a certain style, keep that style's motifs throughout. If you don't, you will lose points and be branded miscellaneous. And that's not good.

* **Balance:** Each piece has its own type of balance and should be cool to look at. It can be formally balanced straight ahead or informally balanced with multiple viewpoints; meaning that the eye follows over the entire piece and is not stuck on just one thing. Try not to make something look like it is flying off the page or the wall unless you expressly want that to happen.

* **Contrast:** Black and white are colors in graffiti. Blacks should be positioned to look as black as possible and whites positioned to look as white as possible. Contrast is achieved by value and visual information, small dots superimposed over bigger dots, for example.

* **Rhythm:** Rhythm depends heavily on color, the choice of colors, and the patterns. Do the colors inside the letter repeat in regions or do they conflict with the backgrounds? Do the colors add to the sense of depth?

1940s
"Cholo" writing begins to take shape and form in Los Angeles, California.

DO: Keep your pieces bright, intense and active.

DON'T: Allow for too much darkness or drab, static pieces.

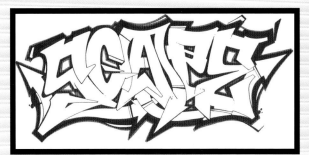

The Components

Here we have the character from earlier, as well as the letters and a background. Study how they work individually; also understand that no abstract elements were used.

The Piece

Voila! When all three are put together, we have a piece. Notice how a little tweaking can make the letters flow better? Adding a few details like an extra glow not only brings out the piece, it also ties the character to the letters.

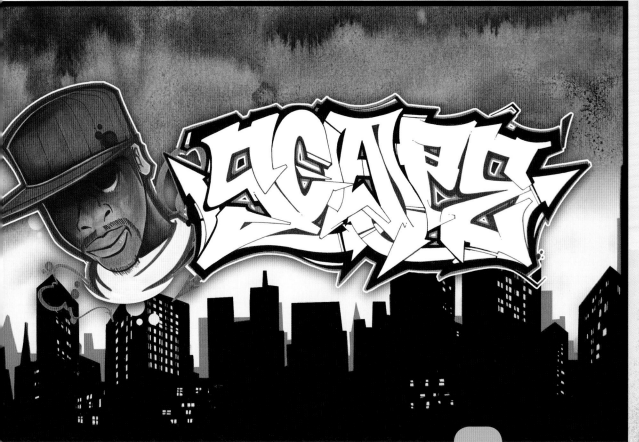

1940

Urban culture photographer Henry Chalfant is born in Pennsylvania. He goes on to publish the important books *Subway Art* and *Spray Can Art*. Chalfant also co-produces and does background research and photo-documentation for the film, *Style Wars*.

The Components

OK, let's try it again. Here we have the 3-D letters, the breakthrough background and, instead of a true character, we go with the Egyptian eye.

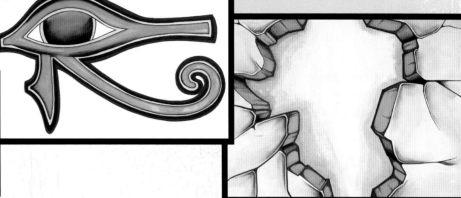

The Piece

The background alone introduces two planes. The 3-D letters introduce even more perspective to the piece. All this activity allows the eye to float.

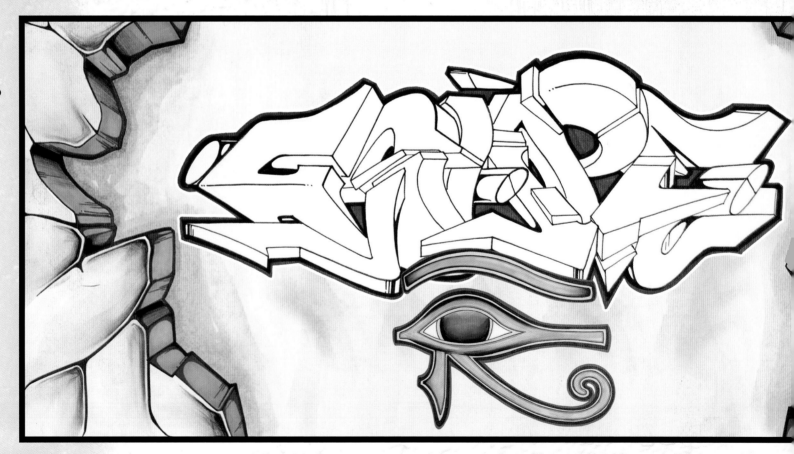

MY THREE SUPREME RULES FOR CREATIVITY

1. **PRACTICE, PRACTICE AND MORE PRACTICE.** If you suck, it's your own fault. Not mine, not your parents', not the clowns' down the street.

2. **KEEP YOUR MIND OPEN.** You are in the middle of drawing a 3-D wildstyle piece and you are stuck. Writer's block. Your friend comes over and invites you to go on a drive to get some fresh air. You say "No," then spend the rest of the night wrestling with a stubborn letter pattern. You were better off taking the ride. Never underestimate the influence, both positive and negative, of the natural world to your artwork. Let your mind flow free.

3. **BELIEVING IS SEEING.** When you approach a blank canvas, sketchbook or wall, you must realize that you are simply making physical what you already know to be true in your mind. You know it already; all you have to do is make it real for everyone else to see.

Another Look

Here is another view to promote the idea of layers and perspective. Each element (character, letter and background) has its own space to do its thing, but must work together as a cohesive whole. Many times, when you try to treat everything on one level, your piece can look flat and less than spectacular.

1941

Lyle Goodhue and William Sullivan develop the modern spray can.

Vaughn Bodé is born. He goes on to become one of the most influential cartoonists of our time. Writers like **SEEN, TRACY 168** and **MARE 139** make his work popular.

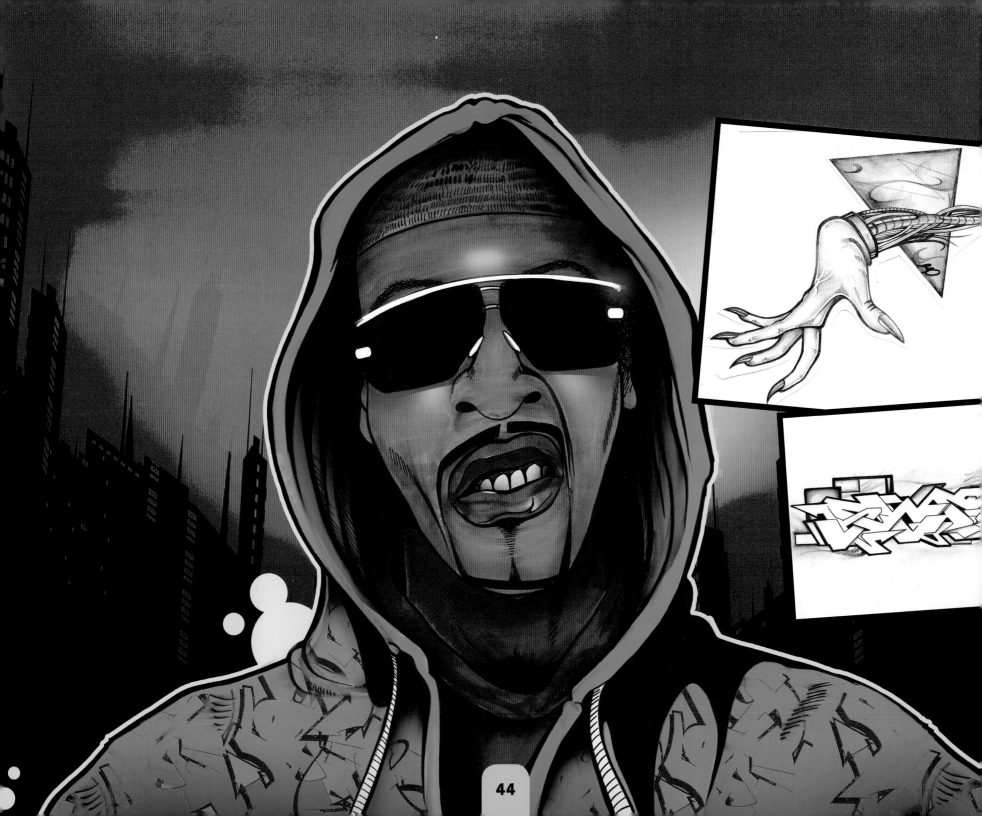

2 FROM SKETCH TO PIECE

This is the whole process.

You begin with your idea. Dig into your brain and juggle the ideas around. Then grab your pencils and markers, get your blackbook and sketch papers, take a comfortable seat some place and sketch.

Many times, I doodle throughout the day and save all the ideas. Sometimes I don't have my blackbook nearby but I may draw on a random sheet of paper. Later, I paste all the images into my blackbook and create a sort of graffiti collage.

As you lay out your ideas in your sketchbook, begin to think if they are going onto a wall or other surface. Fill your sketchbook with drawings, ideas and thoughts. It's not uncommon for your piece book to be equal parts artwork, personal journal and scrapbook.

Add color to your sketches as you see fit. Experiment. This is the place where you can do that. Combine your markers with colored pencils and some permanent ink and see what you get. Sketch letters in pencil and outline them with a fine-tipped permanent marker so you can add color with no smearing.

You may want to keep each element of your piece on a different sheet. Your letters on one, your character on another, and a splash page with your background.

Or you can keep it very loose, where you sketch out your letters in pencil and simply write in your color concepts like a recipe. This leaves room for on-the-spot improvisation, which for me is a lot of fun.

After you are done and have your sketch, you are ready to go to the wall and begin piecing.

1946

The legend of "KILROY WAS HERE" is reportedly solved says *The New York Times*. The originator (or at least the one who claimed the prize—a trolley car—is named James J. Kilroy. He worked at a shipyard where he scrawled in white chalk on the ships. These found their way throughout Europe during World War II, and as American forces took back towns, soldiers wrote "KILROY WAS HERE" on whatever wall was left standing. Later, "KILROY" becomes synonymous with graffiti, finding its way onto countless notebook covers. Of course, lots of other theories still exist.

HOW EXPRESSIVE IS YOUR LINE?

At its most basic, the line is the building block to represent objects, to visually signify and to mark territory. Expressive lines and marks are full of life and significance. We generally think of lines in pencil drawings, but lines are also done in markers, inks and spray paint.

When creating your lines, answer this question: Where are you starting and where are you going? You can't have lines going nowhere and coming from nowhere. Your line is a mark representing a moving point; it has real impact according to its direction, its weight and the variations in its direction.

Lines are versatile; they empower you to communicate, act as a symbolic language and communicate emotion. Your lines are both part of your tag and a necessary element in creating a piece.

Every Line Means Something

This is true with calligraphy in all its forms—especially in graffiti—whether it is recognizable as a representation of words and even when we do not know what the language is. Over time, you will create a real or implied code of your own visual language. Here are some ways to develop expressive lines.

* Vary the thickness or weight of the lines.

* Doodle and compose a few drawings and compositions in your blackbook using only random lines.

* The expressive line has many dimensions to it. Use color to add an extra dimension to the line.

* Your lines can be combined with each other and with colors to create textures, values and designs.

The Goal
This is one of your destinations, to combine lines and make a real statement.

Edge Lines
These are four lines side by side, often found when the edges of your letters meet glows and strokes.

1949

Edward Seymour adds paint to an existing aerosol can technology. Initially designed to demonstrate his aluminum paint, the delivery system itself was instantly popular, and Chase Products Company was the first to manufacture spray paint.

You are taking the viewer on a journey; use the idea of going from here to there, as well as some arrows. Your linear vocabulary will make your point understood.

Following are some ideas about lines and their variations and directions. Practice these types of marks and you'll have all you need to be successful. Don't spend a lot of time on each type, as you may lose your spontaneity. Learn to execute them quickly but accurately, and practice often.

Simple Crosshatch

This works well combined with a rich colored background.

↑ Easy Compositions

Adding the crosshatching with other colored lines, you start to build a basic composition.

Lines Begin Letters ➡

Vertical and horizontal meet with expressive barbs. It's easy to see where your letters can take shape.

Curvy Arrows for Direction ➡

Combining curves with the arrowhead indicates direction with flair.

Objects

When lines meet, they can create objects. Here, these two ovals float over the background.

Layered Curves

Whimsical curves over each other can provide a lyrical feel to your letters or composition.

1950s

After the death of Charlie "Bird" Parker, the jazz musician, the slogan "Bird Lives" pops up across the United States, particularly in New York.

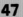

Glyphs
A type of glyph can be formed to add to your code.

Dramatic Lines ➡
Lines like these can provide immediate tension and can break up flat space.

⬅ Flourishes for Edges
Line flourishes can be incorporated on the edges of letters or wrapped around a tag.

Lines to Create Illusion of Depth
A few lines carefully placed and of varying thicknesses provide a sense of depth.

Combinations ➡
Curves, barbs, squiggly lines, jagged lines and parallel lines combine with various colors to showcase the type of visual impact that is possible.

1950
Scientist John Desmond Bernal has a party at his flat in London. He asks a party guest if he'd like to scribble something on the living room wall. That guest was Pablo Picasso. Picasso climbs up on a chair and scribbles and draws on the space above the bookshelves.

PRACTICE LETTERS

Now that you've had time to think about and practice lines, put that into practice with some lettering. Begin with just markers and paper to get a feel for graff lettering. Replicate these letters at first, then go off on your own.

Use your tool of choice. There are tons of markers out there—learn how to use them all!

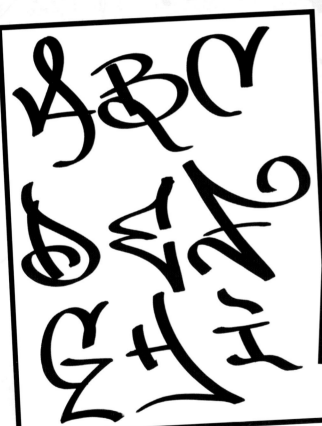

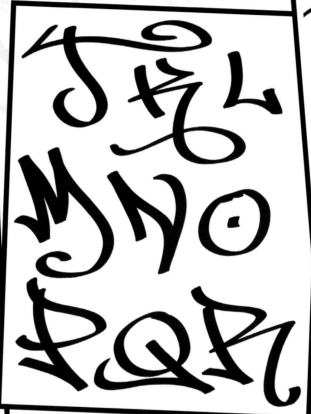

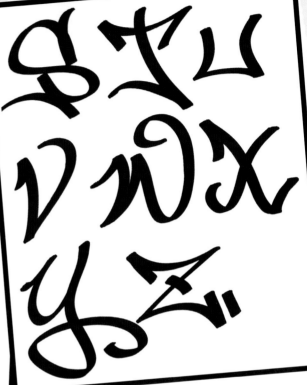

Alphabet Sample
Here is a sample alphabet that can be used as a jumping-off point.

1952
Sidney Rosenthal, from Richmond Hill, New York, invents the marker. He places a felt tip on the end of a small, stout bottle of permanent ink and discovers that the resulting marks saturate a heavy, absorbent surface, yielding rich color and permanence.

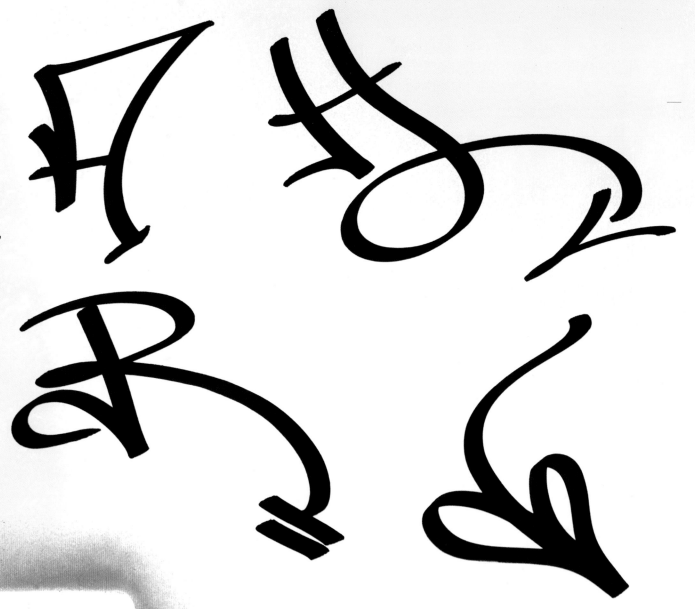

Single Letters

Here are single letter types, to enable you to see their movements up close. Each is different, but they all follow similar patterns. Get yourself used to the hand gestures for each letter.

1955

One of the most famous graffiti artists, **FUTURA 2000**, is born. He begins his career on New York's subways in the early 1970s.

The Permanent Pigments Company develops the first water-based acrylic gesso called Liquitex (Liquid Texture).

PRACTICE

Practice your tag again and again. Let the tag evolve as you look for a balance between the impact of the look and the ease of creation.

Working on Paper

TAG DEMO

It's time to practice your expressive lines to develop your tag. Experiment to find a marker that works for you. See how it feels in your hand. Here, I used a classic chisel tip.

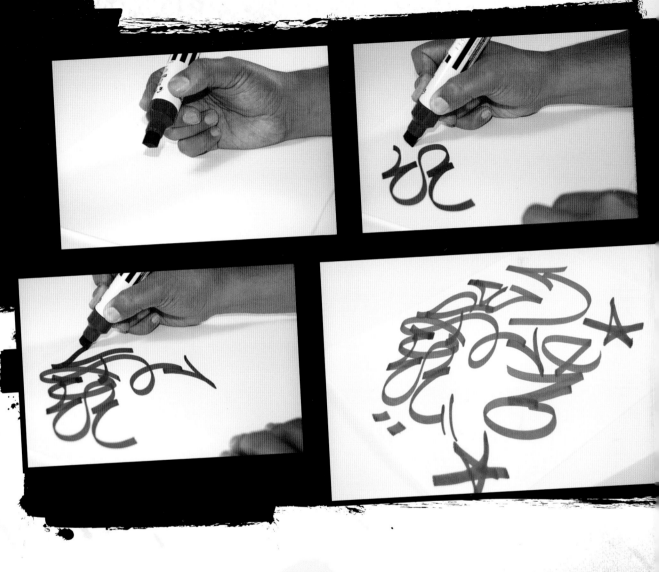

1 Become Comfortable Holding the Marker
Make sure the chisel tip is facing down and that the body is filled with ink. Graff artists often fill brand new markers with even more ink to create what we fondly call a *juicy marker*.

2 Start the First Letter, Slowly
Feel the connection. The marker is an extension of your hand and the hand is an extension of your mind.

3 Follow Through
Your movements should flow. Even if your tag contains sharp angles, run the tip of the marker smoothly over the surface to make a bold imprint.

4 Add Flourishes to Wrap It Up
Add symbols and extra marks. The chisel tip, with varying line thickness, makes the lines visually interesting.

1956
The Permanent Pigments Company develops the first commercially available water-based fluid acrylic colors.

Much of letter development occurs in your head. You must work on your visualization skills so you can grasp lines, shapes and forms, and how they work as part of letters.

Probably the most important concept in developing your letters is the recognition that there is some kind of structure, theme or style that ties all the elements into a discernible message. It's all about the process. Sure, you want to see the end product, but much of what you see is the result of many complicated choices and ideas.

Develop your letters in two quick stages:

1 Make a loose sketch to define your space and flesh out your letter-forms. Here, you decide the flow of the letter. The sketch is your foundation. Keep it nice and loose. Add, subtract and don't worry about erasing. Keep in mind the level of tension or energy that will be generated by your letters, the degree of movement, how your eyes bounce around the letter and the whole word.

2 Ink, or solidify, your lines. Decide which lines you want to keep and discard the rest. Straighten out your straight lines and keep your curves flowing. Create your lines in varying weights throughout the form.

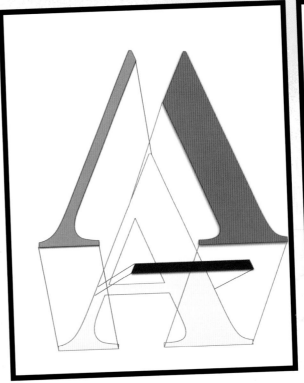

Dissecting Letters

Break up the letters, either in your mind or on a piece of paper, into their most necessary and important parts. That way, you can more clearly see where you can modify the letters. The letter A is fundamentally three parts, as is the R (though it could be two as well). To each one of these parts you can add style and properties. Just remember that if you add a twist to one part, add the same or similar twist to all of them in order to keep the theme and promote balance.

1957
Vaughn Bodé designs the infamous Cheech Wizard character.

THE BASICS

- Search, seek and find balance!
- Look, feel and generate movement!

Dotted Lines Help Balance and Development

Sketch dotted lines from your letterform to keep your letters balanced and your curves congruent. You'll erase these lines later. Study how sections can lie on top of each other and make choices as to how to play with the forms. If you want to stretch one section so that it protrudes over the next, you can do that. Or, if you want to twist the serifs, the extended dots show you what angle would be best.

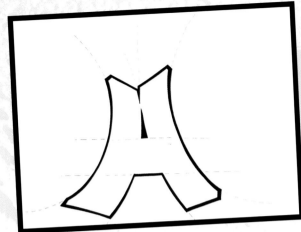
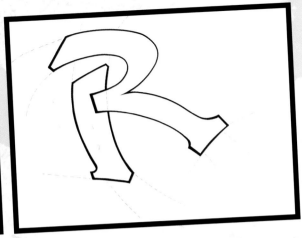

Wildstyle R Sketch

Sketch out a few parallel lines before you begin, to keep the letters balanced. This will help you line up any part that needs to level.

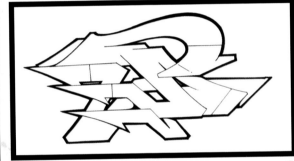

Wildstyle R Finished

Ink the lines you want to keep and focus on the outline. Keep the outline of the letters heavier than the interior lines.

Semi-Wildstyle S Sketch

Work from the general to the specific. Sketch the body of the letter first, then arrows and extensions.

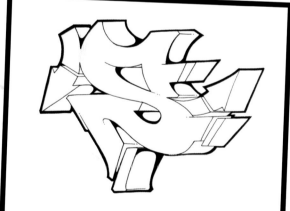

Semi-Wildstyle S Finished

The parallel lines from the sketch help to line up the 3-D with the letters. The 3-D adds to the overall structure and gives the letter mass.

BUILD AN R

Let's start with an R. From that letter, make a creative leap. Instead of looking at the line, look at the space. Begin looking at the actual shape of the letter. Remember, you are the artist and you are adding your personality to the letter. Keep it strong, bold and full of style. Let's get busy!

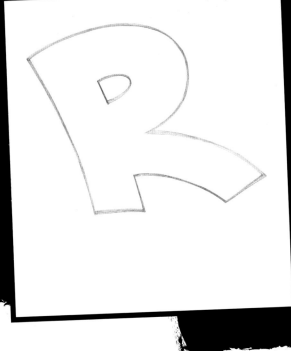
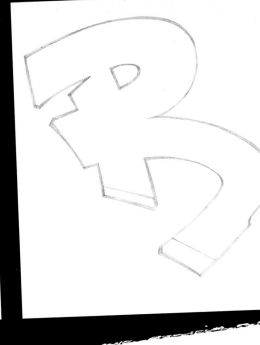

1958

Rosenthal officially names his new marking device the Magic Marker because of its ability to mark on almost any surface. Markers become common as people use them for lettering, labeling, marking packages and creating posters.

Artist Keith Haring is born in Reading, Pennsylvania.

Michael Tracy is born. He goes on to become the legendary old-school writer, **TRACY 168**, and begins to lay the foundation for wildstyle.

1 Draw the Outline
Create the letter in a thicker, chunkier fashion. A simple thick, blockbuster style letter.

2 Flex It
Begin the flow of the letter. Stretch the leg forward and bend it back. Stretch the top back and cut a bit off. Borrow the style from the tag (page 50), bringing it right back.

3 Add Arrows
Add three arrows, keeping the flow of the letter in mind. Don't add arrows that will fundamentally change the letter. The R should stay an R and not become a B or anything else.

4 Draw More Arrows
Seven arrows total; five different types. Three arrows are grouped together on the left, an extra arrow is peeking from under the previous one, and a chunky arrow is added to the leg, which is cut off. Also, look at how the back of the R is sliced and pushed up to give it its own identity.

5 Define the Outline
Outline the letter in black ink and add a drop shadow. Be confident with the final choice of outline. Use a permanent black marker such as a fine-tip Sharpie. Change the weight of the line as you go around the letter to add character. Finish erasing all pencil lines.

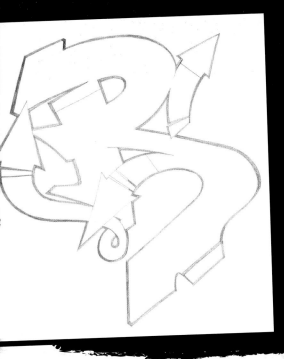

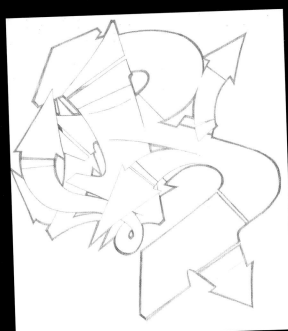

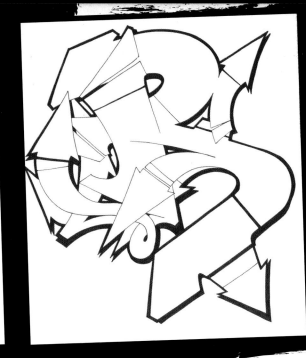

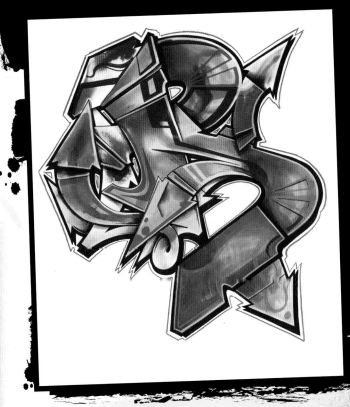

6 Add Final Colors

I went with shades of blues, purples and pinks with concentrated watercolors and colored pencils to great effect. Adding color increases legibility—or illegibility—so color to your taste. When you add shadows or a shine, remember to keep the light source consistent. And add a glow.

WHAT IS FLOW?

The flow of the letter is the movement and direction of the letter as a whole and its pieces individually. Similar to the way a tree has a trunk that breaks off into branches, then into leaves, then into foliage or fruit, such are your letters to your arrows to your extensions and flourishes.

1959

The Feuerstein group is founded as a paint distribution business. By the mid-1990s, the company began to design and develop its own spray paint brands and technologies, culminating with the Molotow brand.

BALANCING LETTERS IN A NAME

I have been asked countless times how to create balance in letters and in a name. Are we talking the standard art speak of balance, or are we talking more along the lines of having symmetry with the elements? I believe it's a little of both.

On one level, we must be conscious of eye movement and focal points. Where does the eye go when looking at the total piece? Begin thinking of this even at the concept stage. If the eye is stuck in one area, the piece may be unbalanced. If the eye explores the whole word, you are on the right track.

On another level, we are talking about a stylistic sense of balance, making sure that elements run through all the letters in the word or name and the expressions in the composition. Look at the parts as a theme (arrows, overlaps, extensions, etc.). Don't replicate that theme over and over exactly. Don't put the exact same arrow out of each letter the exact same way and direction, but you do want some kind of continuity.

There isn't a single way to accomplish all this. I can only show you how I search, find and use these opportunities.

I always start with a theme in mind, whether wildstyle or 3-D style. When the pencil hits the paper, I begin with a single letter sketch. And that single letter will have its own identity. It will have its own characteristics, and the balancing and the modifications for the rest of the letters will suggest themselves from the single letter. This helps to guarantee a level of symmetry and compatibility. It's a borrowing concept that works well.

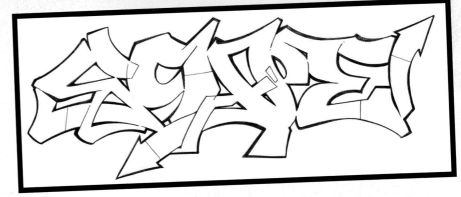

Unbalanced
Here the letters are a bit scattered. Some elements pop here and there, but they are not uniform. The outline isn't consistent.

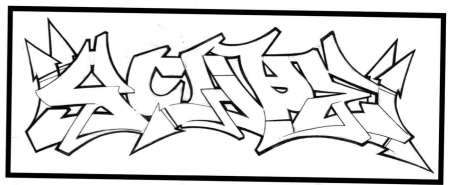

Balanced
A bit better. Because the arrows go from both ends, the outline is more uniform. What needs to be parallel is parallel. Straight lines are straight and the curves are symmetrical.

MY RULES FOR BALANCING LETTERS

1 Start with one letter. From one letter you should be able to get four or five.

2 Always use style elements already contained in the first letter and manipulate them to create the other letters.

1960S
CORNBREAD and **KOOL EARL** begin the era of modern graffiti in Philadelphia. They help define the role of the modern day graffiti writer.

The Liquitex Company begins to offer water-soluble artist-quality acrylic paints to the masses.

WORKING THE LETTER R

Now let's have you sketch a single letter. Look at it, turn it 90 degrees forward, pause, look at it some more. Turn it 180 degrees backward, flip it upside down, look at it some more and see what letters emerge. Look for elements that you can use in other areas. That arrow coming out the back, you can use that again elsewhere; that flourish that shoots from underneath, you can use that again.

1 Begin With a Semi-Wildstyle R
Notice its structure: a single arrow shooting out the back and serifs.

2 Create the Letter A
Flip the R horizontally, then erase the curve and the leg from the R. You're left with the back end of the R. Double that over, keeping the arrow to run through it, and you have an A.

3 Create the Letter K
Rotate the A 90 degrees. Remove the lower right leg. Duplicate the upper right arm and replace the lower leg. Now you have a symmetrical K.

4 Create the Letter Y
Turn the initial R counterclockwise 180 degrees. Erase the lower left leg to get a letter Y. Extend the lower right arm and there you go!

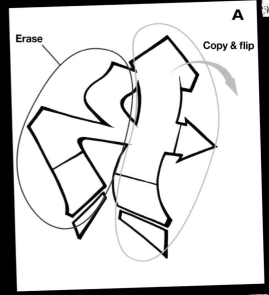

R

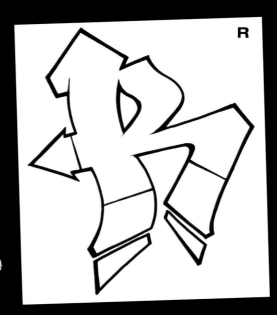

A

Erase

Copy & flip

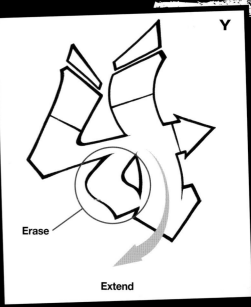

K

Copy & flip

Erase

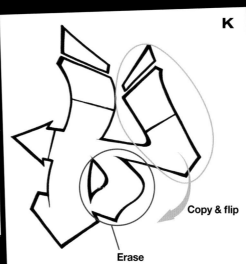

Y

Erase

Extend

INCREASE YOUR DEPTH PERCEPTION: ADDING VALUE AND CONTRAST

Value is relative lightness or darkness. It may have been one of the first things you noticed when you picked up a pencil and started sketching. Contrast measures differences in values. Supreme contrast is the interaction of black and white; all other colors fall underneath those two.

Value and contrast work together. They let the viewer know what the light is doing, and yes, this is important in graffiti. It helps define the shapes of the objects, characters and letters. You will be using black and white as pure colors. Think of contrast as the visibility of the object against its surroundings.

A black shape on top of a white background (such as a black dot on a white sheet of paper) is the most basic and the strongest visual contrast. Knowing this will help you make your letter composition stronger, especially with 3-D letters. But everything doesn't need to be black and white. As you progress, you will learn other methods of contrast, such as shape. Here, I exercised with graphite pencil and black India ink on white paper.

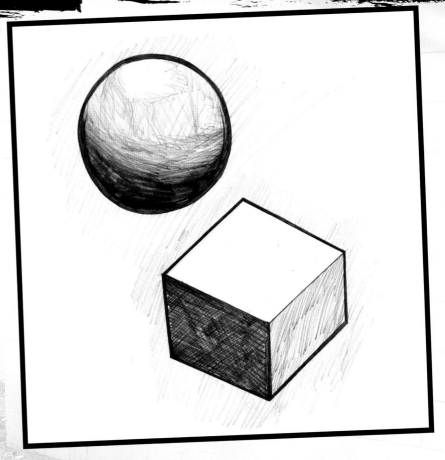

1960

Fred Brathwaite is born, he will later gain worldwide fame as **FAB 5 FREDDY**.

Influential artist Jean-Michel Basquiat is born.

Influential graffiti artist Lee Quiñones is born in Poncede-Leon, Puerto Rico, and raised in New York. Some of his work finds its way into the permanent collections of the Whitney Museum of American Art.

Influential graffiti artist **RAMMELLZEE** is born in Far Rockaway, Queens, New York. His influence works its way into the worlds of graffiti, performance art, rap/hip hop music and sculpture.

The Basics

Using the forms of a sphere and a cube, the shading breaks down into three values. First, consider where the light source is. Here, the light source is in the top right. Where the light hits is the lightest value; the side opposite the light source is the darkest; in between is a middle value. The eye puts it together to make the shape appear 3-D.

Value on Graff Forms

The value ideas you would use on basic forms also apply to 3-D letter elements. The 3-D has a few distinct sides to it: The portions opposite the light or that are overlapped are the darkest, and in between are middle values. Notice on the arrow that there are the similar values to those used on the sphere, with gradients going from light to dark.

Going Black and White

Contrast is not only represented by black and white; different shapes and sizes can contrast, such as the large sphere over the smaller one. The solid black background gives an immediate boost to the objects in front. The contrast in value gives them a sense of space, whereas the spheres appear to float on the edge.

Black and White in Graffiti

These contrasts make graffiti design exciting. A shard of a letter (top) dropped on solid black makes the letter pop. Working with that black—this is key—we mold it into the exiting arrow, creating value difference, contrast and movement. In the bottom piece, the contrast is in the massive dots in the background. They contrast each other because of size and contrast the letterform because of their blackness.

COLOR

Graffiti colors must come on strong and bold and with an edge. They must be a dominant element in the design. You should be familiar with the following main color terms.

* **Primary colors:** red, blue and yellow.

* **Secondary colors:** colors made by mixing primary colors to get orange, green and violet.

* **Tertiary colors:** colors made by mixing a primary color with a secondary color sitting next to it on the color wheel.

* **Complementary colors:** colors opposite one another on the color wheel.

* **Analogous colors:** colors adjacent or close to each other on the color wheel.

When working with colors, articulate your personal style with the letter design *and* the color patterns. Color is the vital element of graffiti style; the energy comes from how colors interact. Start off making color choices that will energize and transform your work. Your color sensibilities and confidence in creating combinations will develop over time.

Colors and their interplay are catalysts for feelings and stimulation. So look at the color wheel and reflect a bit about what colors resonate with you before you begin. What types of colors are they? Are they primaries? And if so, can you work with their complements or analogous colors? An easy trick is to pick your favorite colors and then work with the analogous colors and tie them together with a tertiary color. Confused? Don't be.

With graffiti, color and color theory are based more on physical experiences and visceral choices than abstracted concepts. Graffiti art is based on practice—it's experiential. So the color combinations can be playful, aggressive or even subliminal, but never predictable. See … remember the focus, remember where we are going with this. We're here to create a personal, visual statement.

The Color Wheel

1961

Influential writer Dondi White is born in Brooklyn, New York. Graffiti style changes forever.

The Godfather of Graffiti, a.k.a. **SEEN** is born in the Bronx, New York.

COLORS TO LIVE BY

The following are examples of color palettes in groups of five. Me, I am very influenced by the pinks, purples and blues. As a starting point, these tend to be my dominant colors. I go with their analogous colors for blending, and darker colors like deep burgundies, reds, ultramarine blue and greens as accents. For me, these have instant impact when paired together. And combinations like true blues paired with magentas and yellows pop and generate crazy energy for me.

Color Combinations

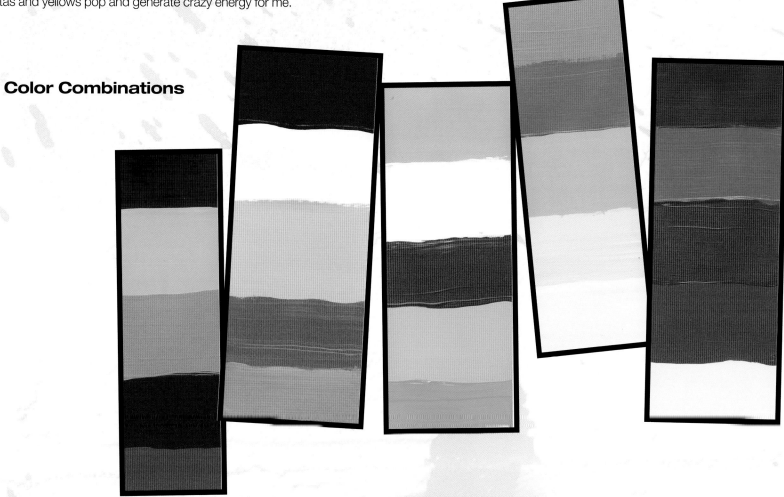

More Color Combinations

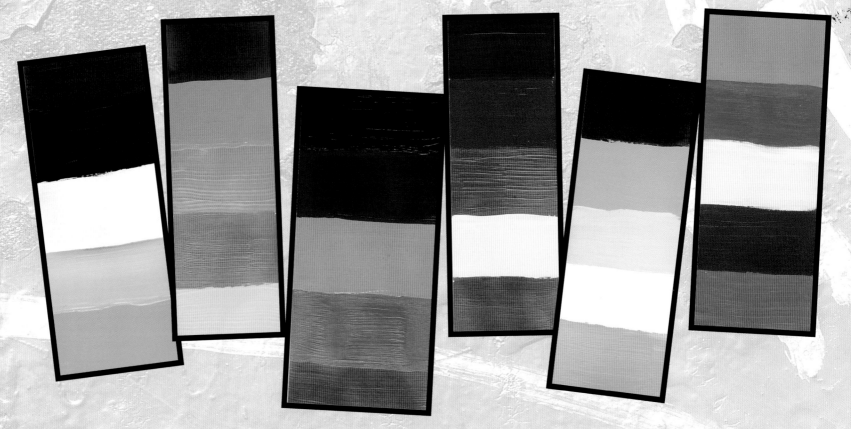

1964

The Sharpie marker is introduced to the world. It becomes the first pen-style permanent marker that can write on almost any surface, from glass to wood to stone to metals and plastics.

TYING COLORS TOGETHER: LOUD AND PROUD

Follow along here for some practice working with colors. In one sample, the letters are very readable, and the second sample, the letters are more wildstyle. One of the key factors here is that the more complex the color patterns, the more complex the letters appear to be. It can make your letters more illegible. Which, when doing readable styles, it's one thing, but when doing wildstyle, legibility isn't a concern. But be conscious of it and explore.

READABLE STYLE: Begin With the Outline

Render the name in Sharpie marker and India ink. The ink is extra-permanent, so it won't bleed or run. The name is readable, and it's funky—a semi-wildstyle, barely scratching the surface of style. The most important thing here is making the outline in various line weights.

WILDSTYLE: Begin With the Outline

Since this piece has a lot more detail, use quill pens and ultra fine-tip permanent markers. Keep your lines clean and crisp, especially in those tight areas inside the letters and where the letters overlap.

2 READABLE: Add the First Layer of Colors

Using markers, lay in the first colors. The base color is the white of the paper. So lay in large bright pink dots. Notice how they cut into all the overlapping. Lay in the orange as long, flowing, lyrical swirls, leaving room for both colors to breathe. Remember, white is the base color, and on the wall, that would be considered the blender. Add lavender to tie it together and stroke the whole piece with blue. See how the colors work together, yet stand apart?

2 WILDSTYLE: Add the First Layer of Colors

In the other example, we generated organic shapes inside the letters. Go in the opposite direction here. Make almost architectural shapes. Line up the light pink to the edges of the letters and let the colors cut through the forms. Again, using the white of the paper, pair up the light pink with the baby blue. Add the glow with purple; that will contrast with the sharp angles of the pink causing a lot of tension and visual interest.

DOTS HINT

Paint dots in groups of three: large, medium and small. Two connecting and one floating works every time.

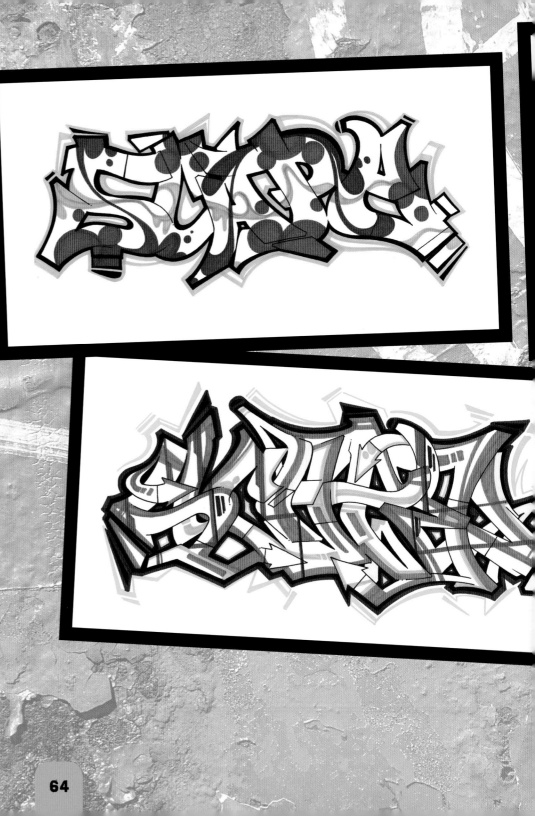

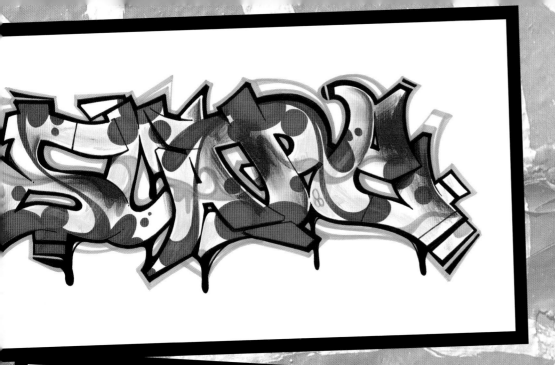

3 READABLE: Finish
Add drips with a fine-point black Sharpie. Add shading with yellow and red colored pencils. Both of those colors will work as they can be blended with the rest of the palette.

3 WILDSTYLE: Finish
Add more shades and blends with colored pencils. Work from left to right, accenting the lines and shapes from the previous shapes. Add some strategically placed black dots on the inside; the eyes will bounce around the entire letter pattern. When tying colors together, you can always use some black. Keep shading the insides and overlaps. And then there you go … voila!

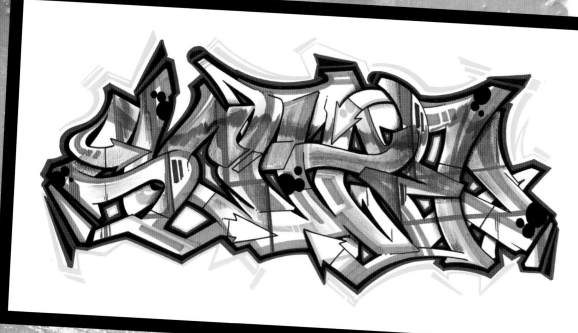

1965
The Metropolitan Commuter Transportation Authority (MCTA) is formed in New York City, later to become the MTA, the Metropolitan Transportation Authority. And let the games begin.

BRING THE NOISE, BRING THE PAINT: A GRAFF COLOR STUDY

How a graffiti artist understands and manages color tends to be the result of in-the-field life experiences and word of mouth. A writer tends to go for a visceral gut feeling type of reaction. It has little to do with intellectual references and more to do with emotive and visual points.

When a group of writers is huddled together discussing styles, very seldom are the perfect rules of color theory discussed. Colors are broken down in very simple terms, whether they work or not. Does it look good or not? There's not really any need to go into the rationale behind it.

But over many years of word of mouth and in-field practice, certain guidelines have emerged. Now remember, what works on paper may not work exactly the same way on the wall since the composition of the paints is altogether different. On paper, you're working with inks, markers and watercolors, so you're confined in certain ways, such as blending and fading your colors. But you can get fantastic results when doing artwork on paper, too—results that you can't get on a wall.

What I have laid down as a color study is not by any means the law of the land. It's just a series of guiding principles and ideas to help you. Look at what your inks and paints do, then learn from it.

The purpose of the color study is to learn some practical applications of color in the physical sense, not some abstract theory. They either work or they don't. Sometimes these ideas vary from person to person and from project to project. The two key ingredients are experimenting and experiencing. Experiment with mixing mediums (watercolors, markers, paint pens, colored pencils, etc.), and experience how they interact with each other. This will allow you to anticipate what colors will work, and you will begin to work with more confidence and with more feeling.

SOME THOUGHTS ABOUT COLOR

Dealing with color on any level is a physical activity based on physical qualities of physical substances, both on the wall and on paper.

Recognize the physical attributes of your materials—the inks, how transparent they are, how lightfast, how strong in tint.

When working with watercolors, water is used to lighten the color of the paint, working towards the white of the paper. So, in action, the whiteness of the paper is a part of your color palette. Practice mixing your colors on a separate sheet of paper before coloring your piece.

Your color skills will depend on many things, but the two most important are patience and practice. Working with color is a process; so let it work, and enjoy the process!

1969

JULIO 204 and **TAKI 183** begin tagging up Washington Heights in New York City.

STAY HIGH 149 begins writing in The Bronx at the age of eighteen. His symbology halos and stars and hand techniques made a lasting influence on generations of graffiti artists.

COLOR STUDY: FLAT

Follow along to learn how color can work in a flat (as in not 3-D) application. You can use any combination of colored pencils, ink, markers and watercolors here. I used a combination of all of these.

Begin With an Outline
Starting with a fluid design for the letter S, ink it using any permanent ink or marker, but make sure that it doesn't bleed or run, and, most importantly, that it won't reactivate when wet.

Drop In the Base Color
Working with a light blue base, water it down a bit and wash the letter. Let it dry to the touch.

Add Details
Watercolors, markers and colored pencils are transparent, so work from light to progressively darker values. Add some more color with purples and deep blues.

Finish
Go over the letter with colored pencils and add shadows and a final stroke of yellow.

TIP

Place art on paper under a reading lamp to quicken drying times.

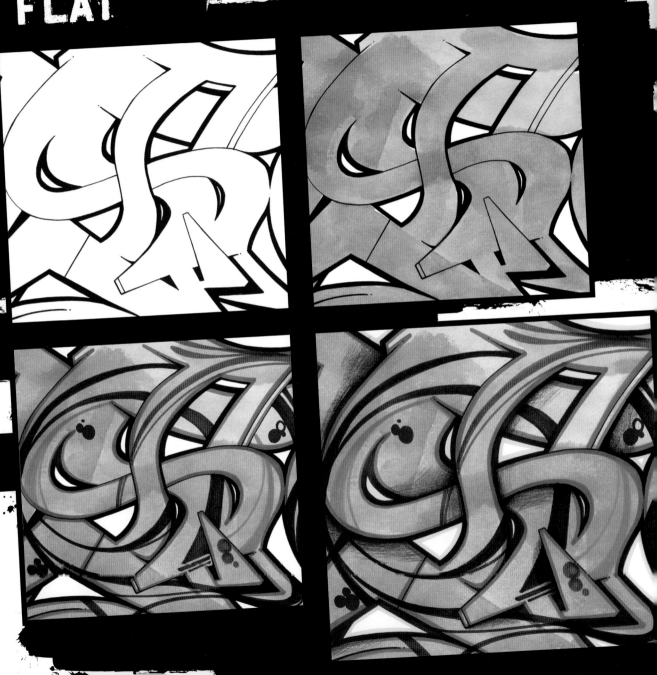

COLOR STUDY: 3-D

Now see how color can work in 3-D with this wildstyle A. Again, you can use any combination of colored pencils, ink, markers and watercolors.

1 Sketch and Outline
Use black ink or marker, varying the line weight throughout the work.

2 First Level of Color
If you use watercolors, use a very soft watercolor brush. I did the 3-D with markers.

3 Second Level of Color
Add darker greens, a bit of yellow and blue. Here, you can see how the transparency of the colors allows them to work together and against each other. Add red to the three-dimensional spaces.

4 Finish
Add fades and shadows (I used colored pencils). Add glow and wrap the entire element in blue.

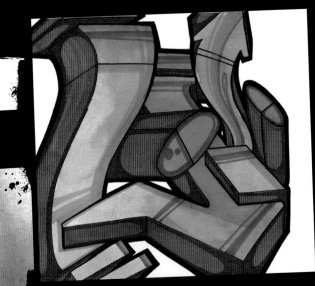

1970s

Toy markers become popular with writers. These were at the most ¼" (6mm) in tip width. Black ink was the color of choice.

Martha Cooper begins to document the New York graffiti scene. Her work culminates in the book *Subway Art* (Henry Holt, 1984).

With color, sometimes what works on paper doesn't work on the walls. With walls, usually the paint is opaque, and on paper it's mostly transparent. But this simple system has always helped me decide what colors to use and how to incorporate them. I call it *the 1 system*: 1 above, 1 below, 1 to unify it, 1 to set it off.

Here's how it works.

1 Choose a base color. This is your primary fill color.

2 Pick one color "above" it, a *darker value*.

3 Pick one color "below" it, a *lighter value*.

4 Choose a color that will tie the three together, a *unifying* color.

5 Look at those four colors as a whole and pick a color to *set those off* in outline.

Each element and color choice is based on the previous step. So your fills will go in one direction, your outline in another, then the glow is based on the previous outline and fills, then the whole element is placed on a proper background.

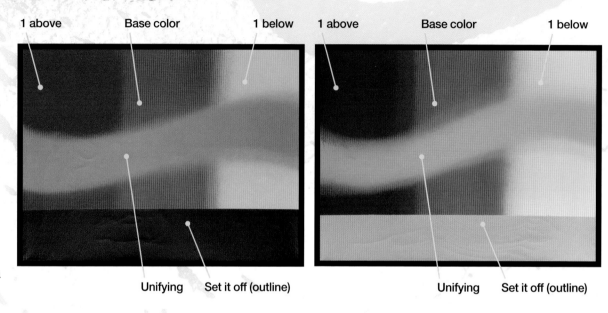

1 above — Base color — 1 below 1 above — Base color — 1 below

Unifying — Set it off (outline) Unifying — Set it off (outline)

Color Study #1

Here the base color is pink. From pink, go "above" to red and "below" to light pink. Bring the three colors together with purple. You can do a lot with purple, as it interacts with the three colors. Ground the entire piece with black.

Color Study #2

Using red as the base color, go a little to the extreme with yellow as one step down, and a deep burgundy as one step up. Orange can work with all three. A cool blue works to set it off.

WORKING ON WALLS: BRINGING TRUTH TO LIGHT

So, picture this: The air is crisp, and the sun is barely coming over the horizon. There isn't a cloud in the sky. It's a quintessential perfect morning. All your spray cans are lined up behind you. You've sorted the colors, lined up the full cans behind the half-empties. All your spray can tips are sorted from fat caps to skinnies. You survey the wall from about twenty feet away. With your pencil sketch in hand, you approach and study the space. You begin pacing from left to right, measuring your footsteps. Each step you figure is close to twelve inches. You calculate in your mind, and you make instant corrections, adding and subtracting. You see exposed plumbing, cable wires and air vents. Instantly you take mental notes, changing your sketch on the spot. Dealing with scale, perspective and color choices, even as you notice the wind blow over the wall and away from you so you know it's going to be difficult to work. You grab for your can of light gray. You look at your watch: it's 7 A.M. and you need to be done today, in one shot. It's just you and the wall. Eight hours and you are done. Eight hours.

This story is a peek into your future.

Now you're ready for the next level. You've studied hard and worked out many styles on paper, and now you want to graduate to walls, but you have doubts and questions. You wonder how all that stuff gets done with limited colors and limited time.

Let's take it one step at a time.

Working on walls can seem a million miles away from working on paper, and in some ways, it is. It is a leap. Do not be discouraged. It takes practice and mistakes will be made. Be prepared to practice, practice and practice.

Other things to remember:

1 QUALITY: Keep your styles sharp.

2 EXPOSURE: Always look for eye catching and bold areas to paint.

3 QUANTITY: You can never have too much of a good thing.

When working on a wall, artistic expression is still the number one objective. In the beginning, it's tricky because there are only so many different colors of spray paint available. One thing you will learn over time is to mix and match different brands of paints and their colors to build the widest color palette possible.

1971

The New York Times July 21 publishes **TAKI 183** article "Taki 183 Spawns Pen Pals."

PHASE 2 begins his graffiti career, and in late 1972 is the first to use bubble letters.

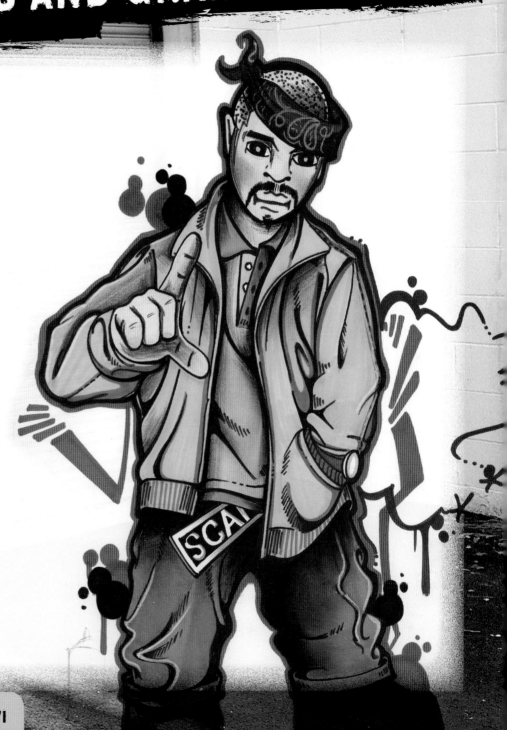

In graffiti, you use materials (spray paint) that are very durable and long-lasting. Yet you know that many times it doesn't last long. Your work may have a lifespan of a few hours to a few years, with the outside world deciding many times just what to do with it—legal or not.

This is the transient aspect of graffiti.

Traditional Murals

With traditional murals, the artwork lives long after the creator passes. But graffiti art survives in photography and folklore, becoming, in a sense, part of an oral tradition as stories of escapades are told, and photos are exchanged of pieces long lost—and in the digital age emailed all across the world.

Traditional mural making tends to be a more visible community-building event. A lot of communicating between parties occurs during the creating: build up, prep and execution. There are processes involved with the community that help build bridges and community engagement.

Graffiti

The graff writer's community is underground. A graff writer tends to record the city's subconscious.

As you approach the wall, remember that graffiti is empowering. Go around town and scope out the city and see it in different ways. Everything is a backdrop. Look at things, not as they are, but as they could be, or should be, with your name written on it. Ask yourself, who is able to express themselves in the public space, and why or why not?

In the end, I don't believe that traditional muralists need to compete with or discount graffiti artists, nor should writers disrespect classic mural making. Both can learn from one another as they already share a common history, and, in my opinion, will share a common future. So let's join together and push each other's agenda forward.

Just remember, you can do it. This is why you were put on Earth. This is all about you. There is no room for doubt, for discouragement. It's you against the world, so whatcha going to say?

SURFACES

The definition of graffiti is the application of markings on a surface. Your artwork is only as good as the surface it's placed on. Graffiti can be executed on any surface, whether real, imagined or even virtual. Whatever surface you use should be clean. It doesn't have to be perfectly clean, but it should be relatively free from loose dirt, mud and dust. You want your paint on the wall, not on anything that can chip or fall off.

The best type of exterior is a primered cinderblock or brick wall. Primer is especially important on wood. Never paint on exposed wood. The bricks of the wall can be used as a grid pattern to make sure your lines are straight and your work is in proportion. The primer will prevent the paint from soaking into the wall, and the brick wall will have a tooth (slightly rough). A slightly rough surface prevents dripping, as the paint can settle in the nooks and crannies. That is a common mistake many writers make, choosing a wall that is so slick the paint drips too easily. This happens a lot when painting on treated metal surfaces.

Go Over Everything

There is a concept with graffiti art that once you begin to paint, you don't stop until complete, and everything in its path gets smothered with styles. Meaning that once you begin, if you bump into hanging wires, cracked surfaces, open-air vents, exposed plumbing, or anything else, you paint over it. It disappears, gets swallowed up by your piece making and becomes part of the canvas.

Remember that the surface is a part of the overall graffiti equation. Your styles come out of your mind and onto your paper. From your paper it goes to the walls. From the walls it goes into the viewers' minds. If the surface isn't up to par, the equation doesn't work as well as it should.

Experiment on swatches of the wall. Manufacturers are always developing paints with different characteristics that adhere to different surfaces better. Never try to do a full-fledged burner or mural-type piece on corrugated walls, or walls that are broken, such as fences or rolling doors. The human eye can fill in the visual gaps, but you can't do detail work on surfaces like these. These spaces are better suited for simpler pieces of art.

Always choose your surface carefully. Prep whenever possible. Clean your surfaces whenever you can as well. This will ensure that the artwork will look the best possible.

1972

Marc Ecko is born in East Brunswick, New Jersey, and the world of fashion design will never be the same.

SUPER KOOL 223 is the first to add clouds to his tag and is credited as being the first to create a full piece.

The term "wildstyle" is coined by TRACY 168.

Hugo Martinez founded United Graffiti Artists (UGA). The UGA consisted of many of the top graffiti artists at the time as they made the effort to present graffiti in an art gallery setting.

HINT

Always primer any wooden surface prior to painting.

The Good: Exceptional Wall Examples

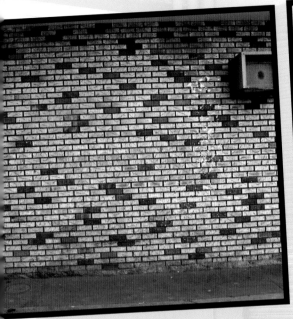

Classic Material
Old school all the way—classic bricks.
But please remember to buff the wall first!

Grid Patterns
Bricks like these are great because they become de-facto grid patterns to keep your artwork accurate.

Sticky Walls
Slightly rough, but your paint will stick nicely to this wall. Also, keep an eye out for exposed pipes, wires and the like.

Just Rough Enough ➡
This low-lying wall is also a good choice as it has a slightly raised and rough surface. Just rough enough to hold your paint in its nooks and crannies.

Rough Enough With a Grid Border ➡➡
This wall is great for two reasons. One, the wall itself has the necessary roughness to hold your paint; and two, the tile across the bottom serves as a grid, so you can space out your artwork easily.

The Bad but Workable

Grooves and Slippery
This surface is broken up too much with grooves and folds. Paint will stick to the slick metal, but not as well as on a good wall.

Corrugated Surfaces
You may be able to work on some basic ideas, but forget about doing anything major.

Too Rough
Paint will collect in all the grooves and cause more drips. Also, it's difficult to do good detail work on a wall like this.

Water Damaged
This surface has a lot of water damage, and under closer inspection it absorbs water and will absorb your paint. You can buff and prep it, but it would take a major effort.

Water Damage + Overuse
The wall has a lot water damage, and it has been painted on too much. You can see tons of ghost patterns throughout the wall.

1973
SEEN begins to work on New York's subway system. His crew "United Artists" make their reputation doing whole cars.

New York Magazine mock contest gives the "Taki Awards" for best graffiti pieces. **SPIN** wins the award for Grand Design.

An article in *New York Magazine* by Richard Goldstein entitled "The Graffiti 'Hit' Parade" is also early recognition of the artistic potential of graffiti artists.

The first "top-to-bottom whole car" is painted in New York City.

The Ugly: Bad Wall Choices!

Beyond Hope
These walls are corrugated, rusted and broken.

Exposed Wood
Never paint on exposed wood. When prepping a wall like this, seal all the break points to have a continuous surface.

Caked With Paint
This surface has been caked with paint for years. It's like the moon's surface, and you don't want even try to paint on that.

Caked With Paint + Gaps
Aside from the layers of paint that need to be scraped off, this wall has major gaps in between the slats of wood and really needs to be simply torn down.

Working with cans isn't just pressing down on the tip. The can is an extension of your hands, and you need to learn how to work it. It's your paint brush. Learn to work it in a painterly, artistic fashion. There are two important points with can control: controlling the pressure exerted by your index finger and controlling your wrist actions. These work hand in hand, just like you would work a pencil in a drawing. Understanding your wrist and its movements, coupled with the pressure from your finger, will allow you to create all the fades and blends, streaks and blurs that graff art is known for.

It's not that difficult, but practice is mandatory. It will all come together before you know it. Here are a few tips and ideas to push you along.

* Always shake your cans well.

* Do a little test spray in the air and onto an area on the wall to make sure it's flowing properly.

* *Never* press down on the spray can tip continuously. Practice working in short spurts and short strokes. This prevents dripping.

* When doing fills, hold the can 6 to 8 inches (15 to 20 cm) from the wall and work in a steady direction: top to bottom or left to right. Overlap your spray pattern by about one third.

* Always work darker values over lighter values.

* Take your time. Use two or three coats of lighter sprays rather than one thick coat to avoid drips and runs.

Proper Grip

Hold the spray can with a firm grip. Make sure your index finger can wrap over the tip comfortably.

Check Your Spray

Spray a little into the air to make sure you get good, even flow and that the valves are clean. Notice that the direction of the spray is a few millimeters under the tip of the finger.

Thumb Spray

Experiment with spraying with your thumb. This is excellent for doing large fills and preventing strain and fatigue on your index finger. Save your index finger for the outline.

1974

The Faith of Graffiti by Norman Mailer is published.

Keep Your Distance

When you first approach the wall, keep 6–8 inches (15–20cm) between the wall and the can.

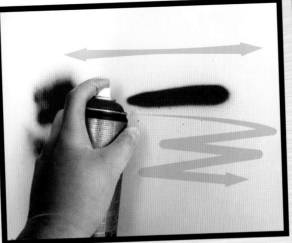

Move Steady

Move in short, steady spurts. Here, I am beginning to create a flow, left to right.

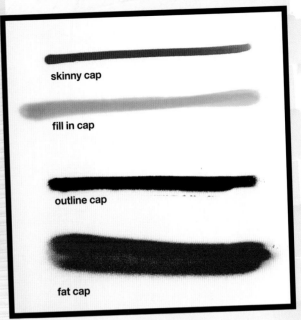

skinny cap

fill in cap

outline cap

fat cap

Don't Forget Your Caps

These four colors represent four types of spray cap widths, from skinny cap (blue) to fat cap (red).

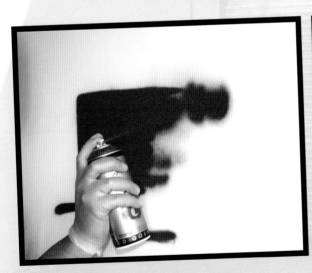

Basic Fills

For basic fill patterns, work your fingers quickly, flexing and applying pressure at the beginning and releasing the pressure at the end of the strokes.

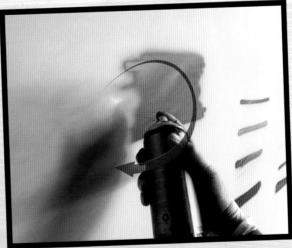

Basic Fade Hand Movements

Tilt the can to the left and, using your wrist in a gentle flicking motion, lay the darker value, in this case limo green over orange.

Work the Wrist

When doing fills and basic fades, the combination of finger pressure, press and release, and controlling the wrist is important. In this instance, keep your wrist in motion, but your elbow and arm stiff. It makes for a cleaner, more even application.

Work the Angles

Holding the can at an angle like this leads the paint to spray a thin film across the surface, allowing you to layer paint for blends and mist.

Simple Gradient Fill, Work Light to Dark

The secret to a successful gradient fill is in the order in which the paints are laid down. Here, yellow, then orange, then red and green. Always try to work from light to dark.

1975

Andrew Witten begins creating graffiti and by 1977 begins using the name **ZEPHYR**. Later he creates the world famous "Wild Style" logo.

Graffiti cult hero, comic book artist "Vaugh Bode" dies, but his legend will live on with graff.

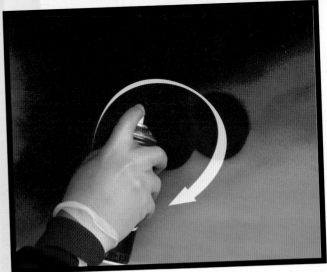

Stay Close to the Wall for Crisp Outlines

Stay really close to the wall and move the can quickly (to prevent drips) for a clean, crisp outline.

Layers

One method of layering is to create dots or other visuals or expressions at the edges of where two colors mix.

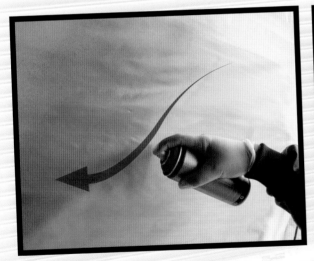

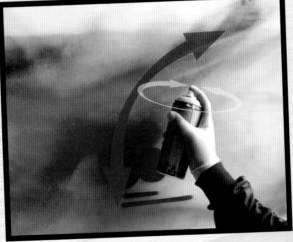

Mixing, Blending and Pushing

When pushing the spray paint further, be savvy with your wrist. Change your distance from the wall as you stroke. Make sure that the colors work well together, and that you use at least three different colors.

Move the Can

Turn your can at various angles and don't worry that some paint will go into the air. You will learn to work with the overspray in time. Lay down your colors over the wall in a cascading effect. In time, all this will become second nature. You'll then be able to add your own unique twists to controlling your can.

MID-1970s

The standard writing marker becomes popular. With a maximum tip width of ½" (13mm), tags are created in a larger scale, and they are refillable, such as the Magnum 44.

Writers begin to use highlights, overlapping letters and three-dimensional effects in their pieces.

THREE DIMENSIONS AND SPACE

Practice your can control with a large sheet of heavily gessoed layout bond paper and a few cans of paint: dark blue, light blue, medium blue and black. Feel free to add others, though.

1 Dark Blue
Begin with a dark blue, the darkest that you have, and fill a slanted rectangle shape.

2 Medium Blue
Paint a mirror image next to the shape with the medium blue. It can be slightly narrow, as in this case, but the two must touch.

3 Light Blue
Paint a rectangle in the "valley" you created. Make sure the edges touch. As you can see, the edges and corners are not crisp. Don't worry.

4 Black
"Cut" out the shape, which by now your mind has identified as a cube. The cutting process sharpens all the edges, and we keep a thick border of black around it to punch it out.

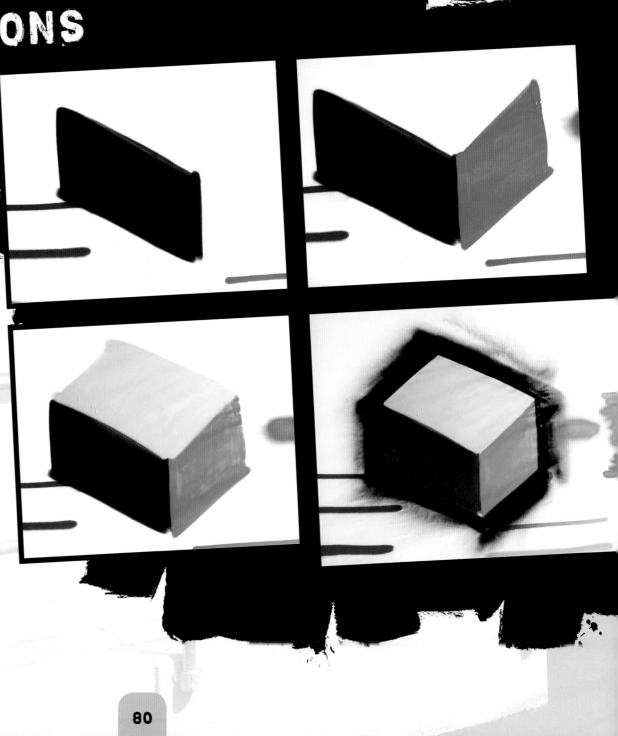

WHAT'S GESSO?

Gesso is used to prep painting surfaces, which gives the surfaces extra strength. You can find it at art and craft stores. There is acrylic gesso and true gesso. For our purposes, acrylic gesso works just fine.

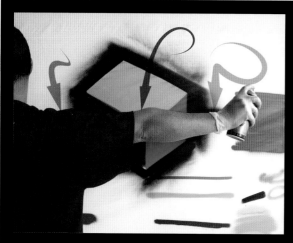

The Power Points

Your shoulder, your elbow and your wrists: Use them to create straight lines and curves the same way you would a ruler and a compass. Paint from your wrist for fills and details. Paint from your elbow for circles and straight lines. Paint from your shoulder for bigger curves and longer lines. Paint from your torso, using your legs and body as a fulcrum, to create very long, straight lines.

A Full Demonstration Wall

1977

Basquiat begins tagging lower Manhattan walls as **SAMO** (Same Old Shit).

TAKE CARE OF IT AND IT WILL TAKE CARE OF YOU

An effective wall prep will save you a lot of problems. Many think wall prep is not a part of graffiti art. Nothing could be further from the truth! For the absolute best results for our creative efforts, wall preparation is a good start. The styles you throw up are only going to be as good as the prep you throw down—what's underneath.

Every wall is different, just as every piece is different. Inspect the wall before you attempt to do anything creative on it. The wall is your canvas, and just as a traditional artist takes time and care to prep his canvas, you will too. You will probably have to primer the wall before you begin. The primer acts like glue for the spray paint to stick to. It will hold the colors to itself and itself to the wall.

1 **Select the wall:** The type of wall and location are of paramount importance. These two factors will dictate what type of graff you will be able to do and how to do the work.

2 **Think about the architecture of the building:** Look for overhangs, exposed pipes or anything that will obstruct or interfere with the flat surface.

3 **Inspect the lighting:** Look for lights, where they are, and decide whether they'll be a hindrance or a benefit to both execution of the work and its run.

4 **Is the wall porous?** Check the wall to see if it's porous, and, if so, to what degree. How many coats of primer are you going to need? It's absolutely necessary to prime a wall if it's porous. Is it even worth the trouble, or can you move on to a different spot?

5 **Is it solid?** Are portions of the wall going to fall away or otherwise interfere with your art? In many cases, these areas require extra coatings of primer before you begin.

6 **Final looks:** Look for holes or excessive dirt. (If you're painting indoors, this is even more important as people will most likely be able to see the work up close.)

Select the Wall
1 The most important first step, pick your wall and do a little bit of cleaning.

Prepare Materials
2 Choose the type of primer and the color. Here, we are going with a nice hot blue. Soak your roller in as much primer as it can possibly hold.

Work In Sections
3 Choose an area to begin and pace yourself. I like to work from left to right, like writing a sentence.

Push The Most From Your Paint
4 Your roller should be saturated with paint to squeeze as much coverage from it as possible.

Step Back and Observe
5 Take a few steps back and see how the paint is sitting and decide how far you want to go with it.

1979
Influential female graffiti artist **LADY PINK** begins writing. Pink paints subway trains from 1979–1985.

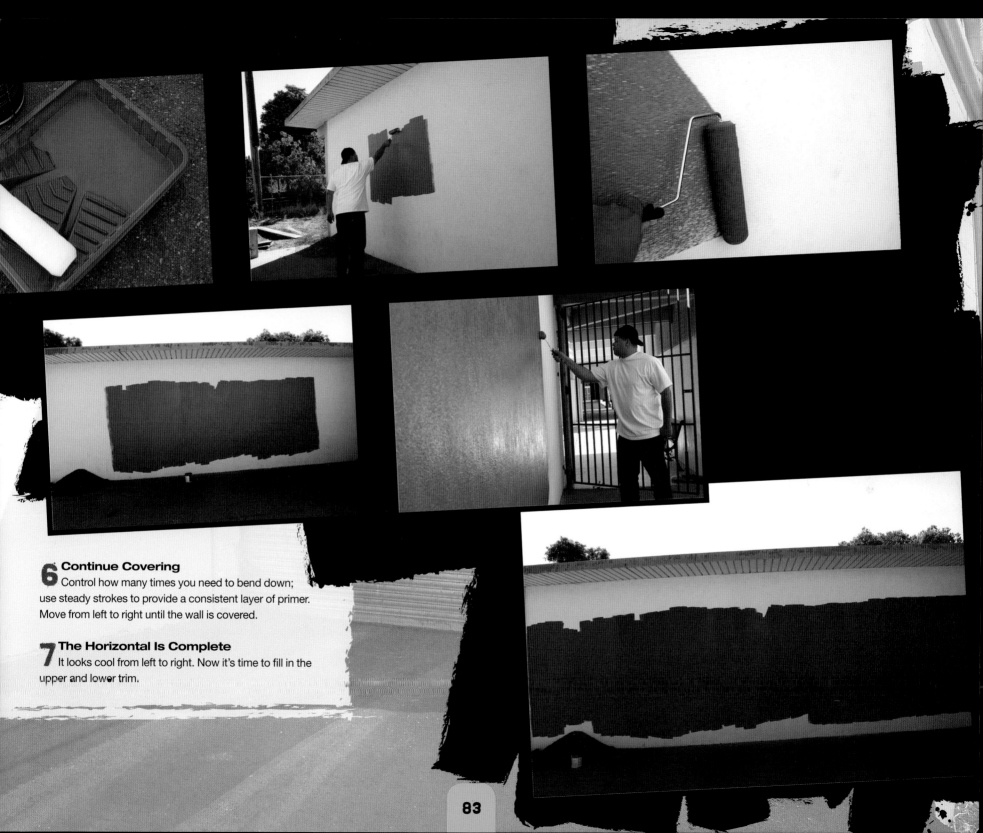

6 Continue Covering
Control how many times you need to bend down; use steady strokes to provide a consistent layer of primer. Move from left to right until the wall is covered.

7 The Horizontal Is Complete
It looks cool from left to right. Now it's time to fill in the upper and lower trim.

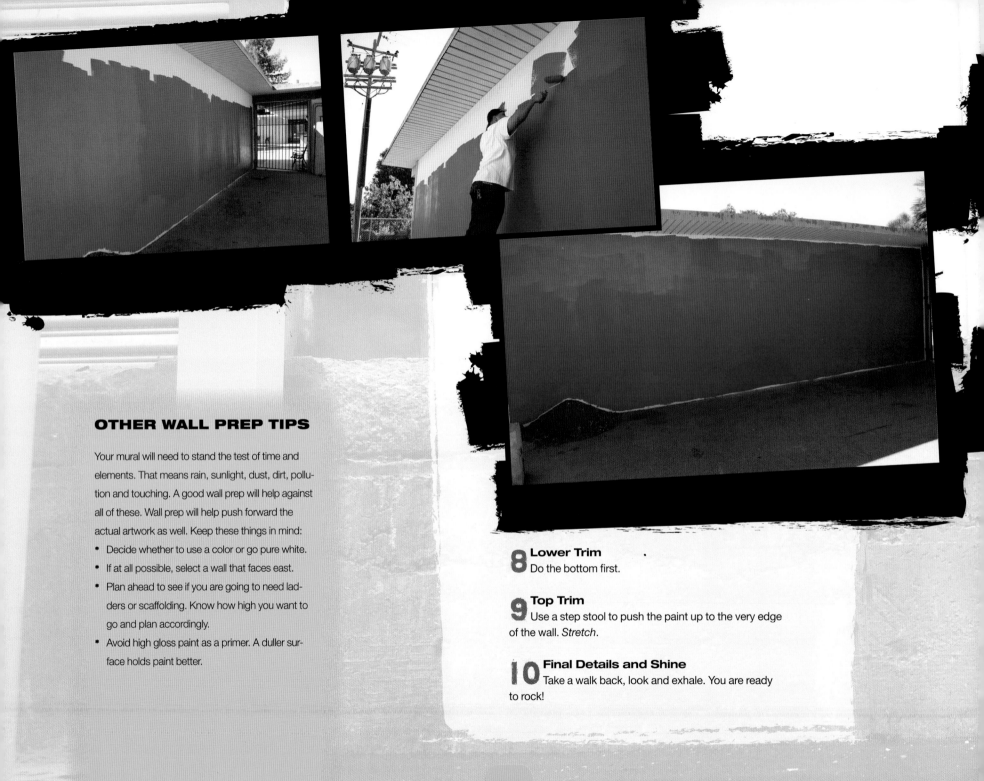

OTHER WALL PREP TIPS

Your mural will need to stand the test of time and elements. That means rain, sunlight, dust, dirt, pollution and touching. A good wall prep will help against all of these. Wall prep will help push forward the actual artwork as well. Keep these things in mind:

- Decide whether to use a color or go pure white.
- If at all possible, select a wall that faces east.
- Plan ahead to see if you are going to need ladders or scaffolding. Know how high you want to go and plan accordingly.
- Avoid high gloss paint as a primer. A duller surface holds paint better.

8 Lower Trim
Do the bottom first.

9 Top Trim
Use a step stool to push the paint up to the very edge of the wall. *Stretch*.

10 Final Details and Shine
Take a walk back, look and exhale. You are ready to rock!

STARTING OUTSIDE

When working outside, you need to know all the components of your work. Learn how the paint sticks to the type of wall you are working with and how you handle the paint. Everything is connected, from the mind, through the arms, to the fingers, through the can and onto the wall.

Be comfortable with the paint; it should feel good in your hands. Be comfortable with yourself; you need to know yourself in all ways, both physically and mentally. You need to be sharp.

Let's start with a semi-wildstyle bar letter pattern with 3-D.

Sketch

This is a semi-wildstyle bar letter pattern. Not too complex, but just enough flavor to start the day off right.

wall color

sketch colors

fill-ins colors

glows and accents colors

outline color

3-D color

background colors

Palette

The wall color is bright blue, so work with that. You want the letters to pop off the blue, so the fill-ins will be yellows, oranges and pinks. White works well with blue, so the 3-D will be white. Then, going full circle, backgrounds will have darker shades of blues and blacks.

1980s

PHASE 2 begins publishing the *International Graffiti Times*, the first fanzine about graff writing.

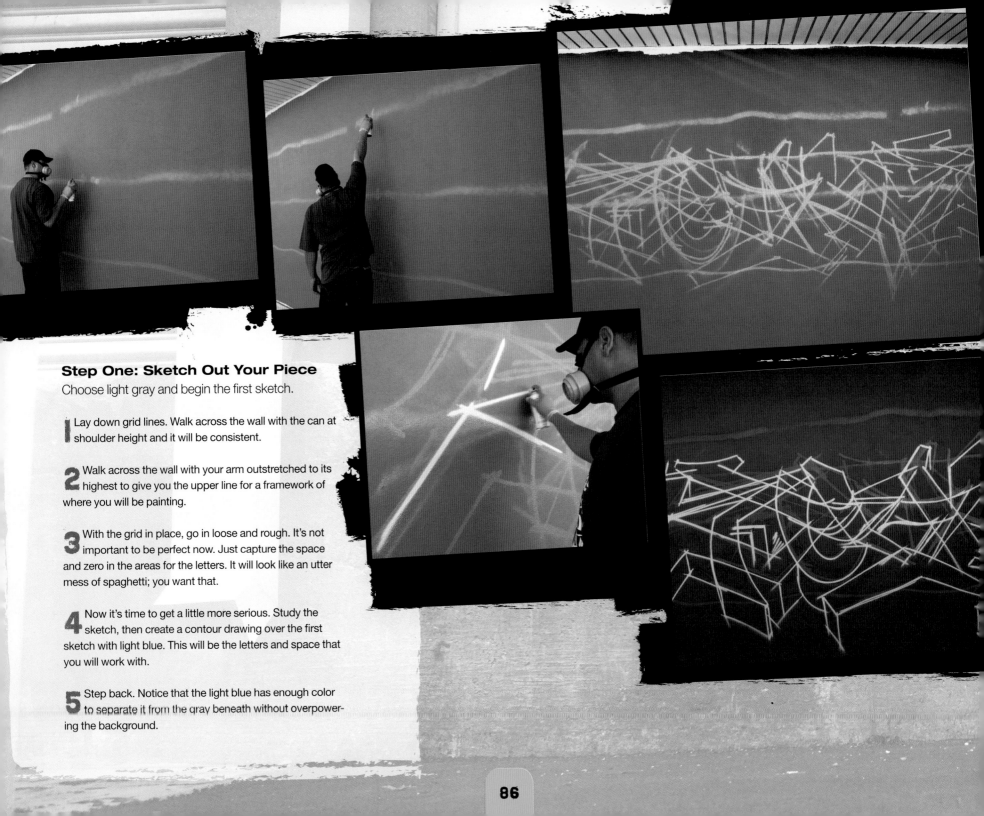

Step One: Sketch Out Your Piece

Choose light gray and begin the first sketch.

1 Lay down grid lines. Walk across the wall with the can at shoulder height and it will be consistent.

2 Walk across the wall with your arm outstretched to its highest to give you the upper line for a framework of where you will be painting.

3 With the grid in place, go in loose and rough. It's not important to be perfect now. Just capture the space and zero in the areas for the letters. It will look like an utter mess of spaghetti; you want that.

4 Now it's time to get a little more serious. Study the sketch, then create a contour drawing over the first sketch with light blue. This will be the letters and space that you will work with.

5 Step back. Notice that the light blue has enough color to separate it from the gray beneath without overpowering the background.

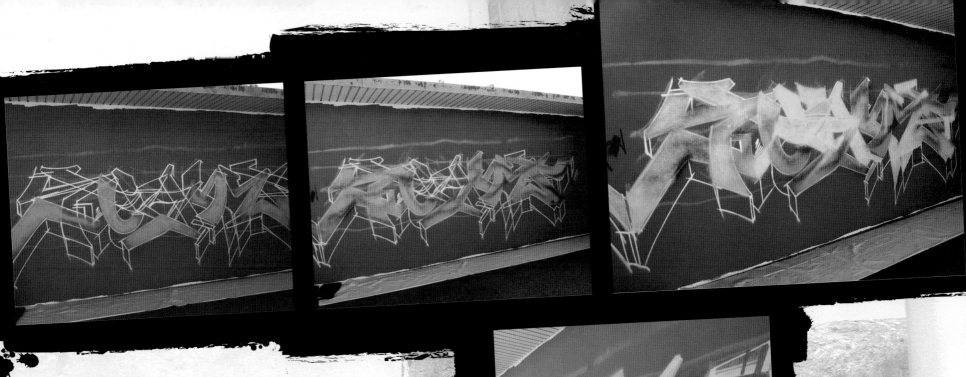

Step Two: First Layer, Fill In Letters

Fill in your letters to completely occupy all the space inside the letter framework. This may be a process of layering, going back and cutting, and blending back and forth until you get to a comfortable place.

1. With basic yellow, go from letter to letter and just touch each letter with the paint; don't completely fill them in.

2. Add pink and blend to the yellow, again not covering the letters completely. Also, give the letters a dusting of burgundy.

3. Complete the first layer with the hotter yellow. Connect, blend and fill in the rest of the letters. It's still rough, but that's OK; this is the first layer.

4. Use three techniques with three distinct colors. With yellow, cut out the letters at the edges, primarily on the right side. Where the yellow isn't, add green bits and flourishes on the insides of the letters. Finally, use orange to add structure to the form.

Correct errors and add details.

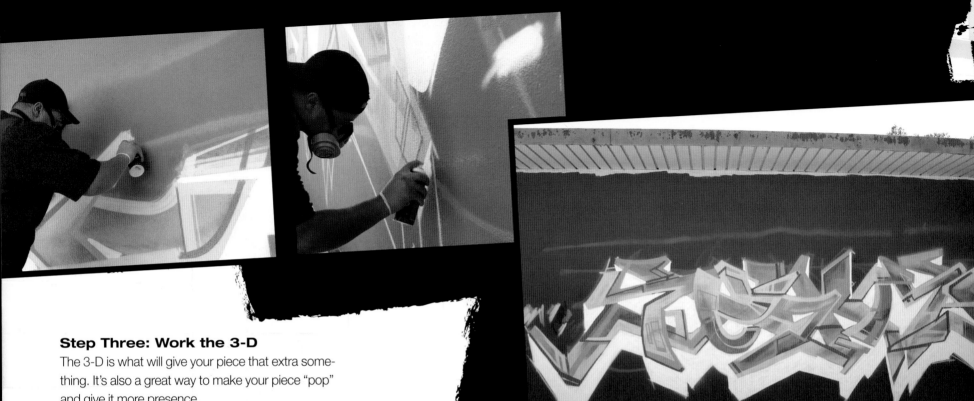

Step Three: Work the 3-D

The 3-D is what will give your piece that extra something. It's also a great way to make your piece "pop" and give it more presence.

1 The 3-D is in white. White is a color here, not the surface peeking out. Give the work special attention. No drips please!

2 As you go along, the 3-D will butt up against the previous color layers inside the letters. Keep those points clear and mistake free.

3 Back away and see how the white is working with the rest of the composition. The white should look pure white—no gray or off colors. Keep your eyes open for overspray that may land on the white. If you find any, paint over it repeatedly until it looks right.

Proper Hand Movements and Angle

Use clear deliberate movements with the can aimed slightly downward, as if you were using traditional paints. Follow the direction of the letter. If the letter is at an angle, as it is here, then the can should be as well

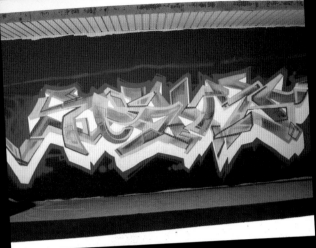

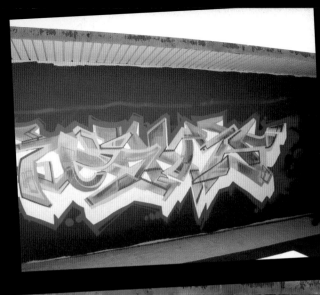

Step Four: Work the Background

Technically, your background is any space outside of the letters and the outline. Some will even consider the glows part of the background—I do! So you want to get all that out of the way before you entertain anything else. Line up your cans and proceed to blend and mix.

1 Lay down some expressive lines and abstract forms to the left of the letters. Immediately repeat on the right side as well to keep things balanced.

2 Step back after you add a glow and ask yourself, "What else does it need? Anything?" I flexed the glows so they break apart and it's more funky.

3 A view to the right: See how the black and the various blues creep into the piece. Notice that the glow worked into the blues. Repeat on the other side, keeping the sense of balance going strong. Feather the black over the blues and purple.

4 Drop in a bit of blue to the insides of the letters, only on the ends of the extensions.

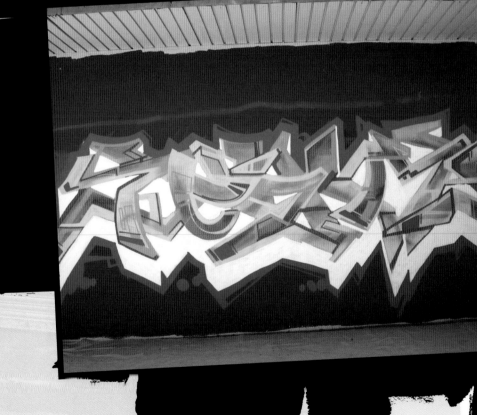

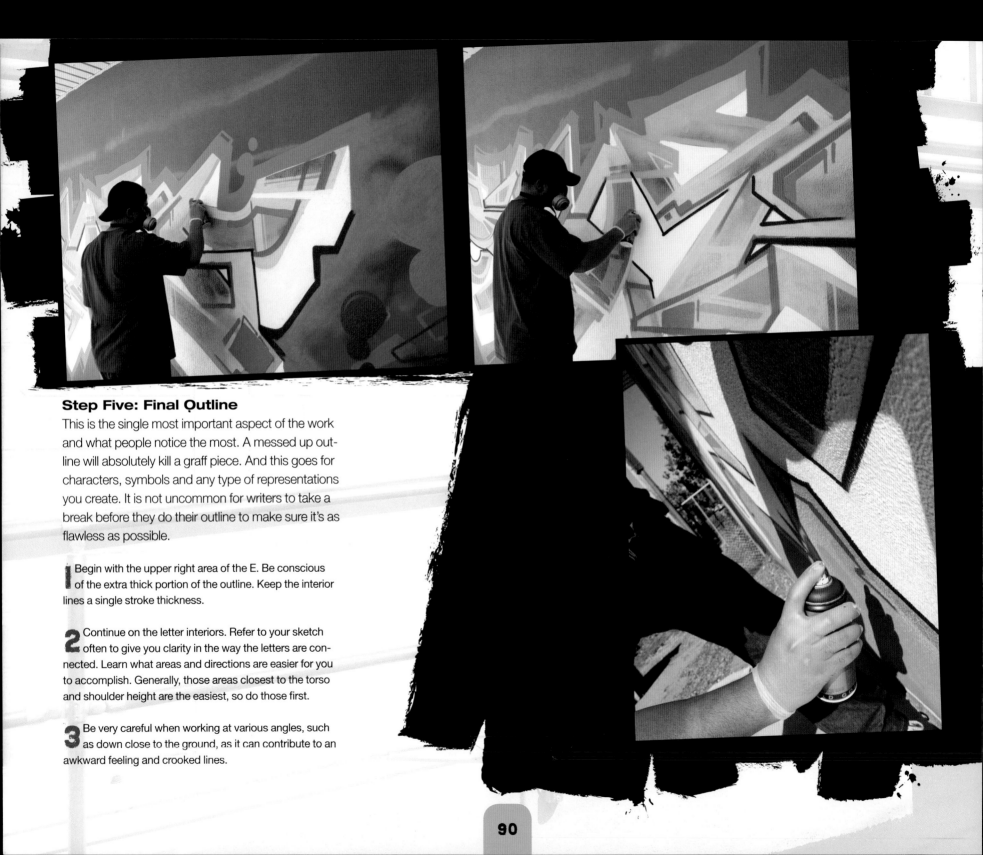

Step Five: Final Outline

This is the single most important aspect of the work and what people notice the most. A messed up outline will absolutely kill a graff piece. And this goes for characters, symbols and any type of representations you create. It is not uncommon for writers to take a break before they do their outline to make sure it's as flawless as possible.

1 Begin with the upper right area of the E. Be conscious of the extra thick portion of the outline. Keep the interior lines a single stroke thickness.

2 Continue on the letter interiors. Refer to your sketch often to give you clarity in the way the letters are connected. Learn what areas and directions are easier for you to accomplish. Generally, those areas closest to the torso and shoulder height are the easiest, so do those first.

3 Be very careful when working at various angles, such as down close to the ground, as it can contribute to an awkward feeling and crooked lines.

Step Six: Final Details, Shine and Finish

Step back and look over the entire piece and pinpoint areas that need attention. Ideas may come to you in the moment that have nothing to do with your sketch or initial color patterns. Capture these; this is the magic. If you get the urge to drop in a few extra dots, shines, expressions or flourishes, this is the time.

And this is crucial: Here is where you make your statement, your quote.

Think about it.

1 Add statements. If you choose to, it is wildly important to sum up your voice in a statement. For this piece mine are: "Graff: the original text message …"—enough said—and "Scape 2007 Always Number One." Since we can be our own worst critics, it's never wrong to be your own best cheerleader.

2 Notice how the 3-D does not have any details. It is superflat by design. Add red strokes at key points for even more energy.

3 Add the rest of the shines, recognizing where the light source is coming from. If it's to the right, then keep it on the right.

4 Add some busy activity in the background. It is really easy to get lost in this type of coloration, so take your time. Back away and look at it from a distance, make your choices and proceed.

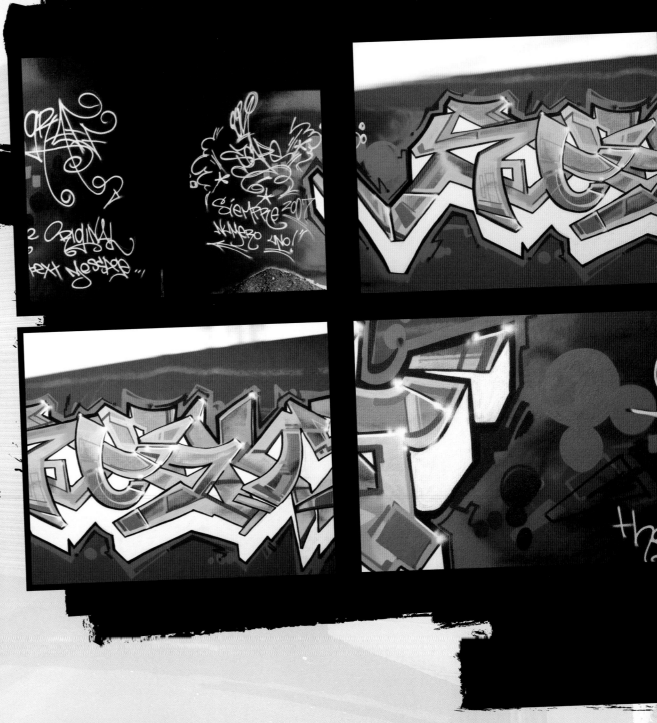

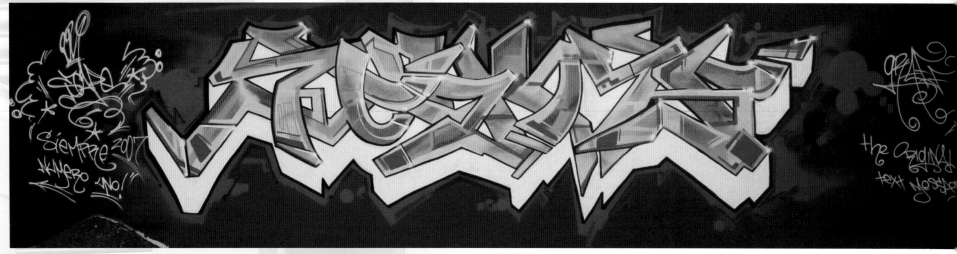

SCAPE, Semi-Wildstyle With Superflat 3-D

This is one of the more basic styles of graff, but it's still busy, and real skills are needed to go at it successfully. Hand-eye coordination and cognitive and decision-making skills are but a few. Practice makes perfect, and perfection is but a journey.

Some of the steps may change as you proceed on your journey, but all in all, the methods pretty much stay the same. Slight variations can and will arise and that's good. Tailor it to suit your needs. Just keep your eyes on the prize: to improve and be a better writer.

1980

New York legend **COPE 2** begins his graffiti career.

Graffiti writer **SEEN** becomes legend by painting the "Hand of Doom" top-to-bottom whole car.

Charlie Ahearn and **FAB 5 FREDDY** begin work on the influential *Wild Style* film.

Jean-Michel Basquiat publicly exhibits for the first time in the Times Square Show in New York City.

Keith Haring begins to create his "subway drawings" throughout the New York subway system leading to worldwide acclaim.

DONDI increases his influence and legend by painting the "Children of the Grave" 1, 2 and 3 top-to-bottom whole cars.

Richard Goldstein of the *Village Voice* writes the important article about graffiti art "The Fire Down Below."

FAB 5 FREDDY paints the world famous top-to-bottom Campbell's soup cans subway car piece. He later finds even greater fame hosting *Yo! MTV Raps*.

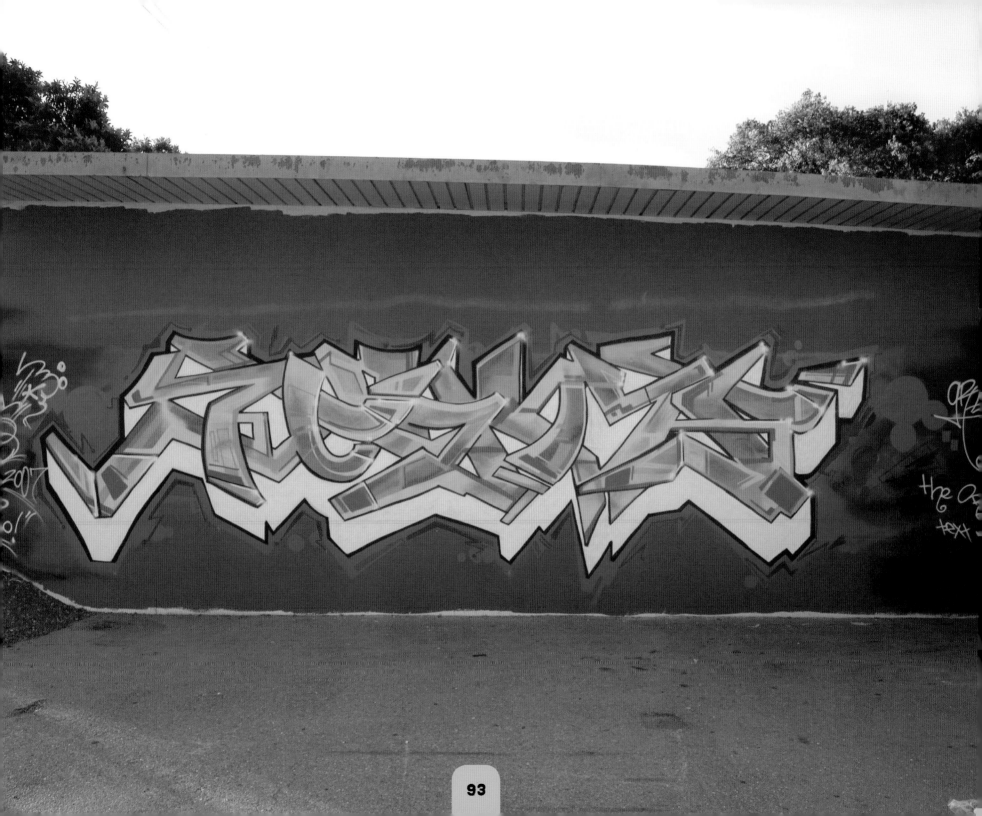

93

ADDING COMPLEXITY

No need to run and get your 3-D glasses.

This a more technical style of graff than your traditional wildstyle graffiti. Over time, as graff styles developed, the idea of using, creating and exploiting three-dimensional space became part of the conversation. So 3-D wildstyle was born! Here, your letters have a greater physical presence, as they can appear to be sculptural in their design. It may even inspire you to actually carve these ideas out of wood or iron, which has happened.

The added presence of the 3-D introduces a complex element as the letters are cut, sliced, diced and cascade over each other.

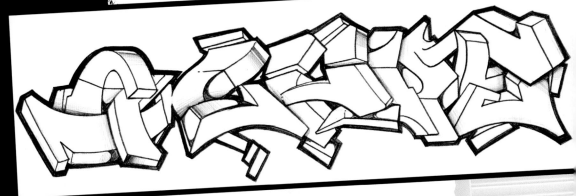

Sketch

There are quite a few challenges in this piece. Capturing three-dimensional letters on a two-dimensional space can be tricky. You'll learn to do this while keeping the integrity of your color patterns intact so the viewer can follow the letters.

Palette

The wall color is bright orange, so fill your letters with colors that will contrast with the orange. That means lots of blues and greens to work with. Always study your wall and base your palette off of that. So, if your wall is a cool color, go with hot colors as fill-ins, or vice versa.

1981

Lee Quiñones becomes the first graff writer to see and exploit the full potential of handball courts, creating murals like "Graffiti 1990."

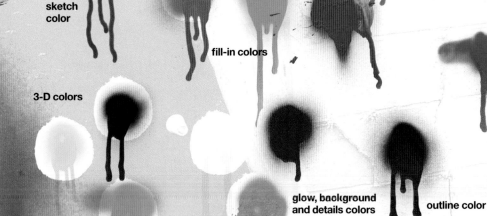

wall color

sketch color

fill-in colors

3-D colors

glow, background and details colors

outline color

accent colors

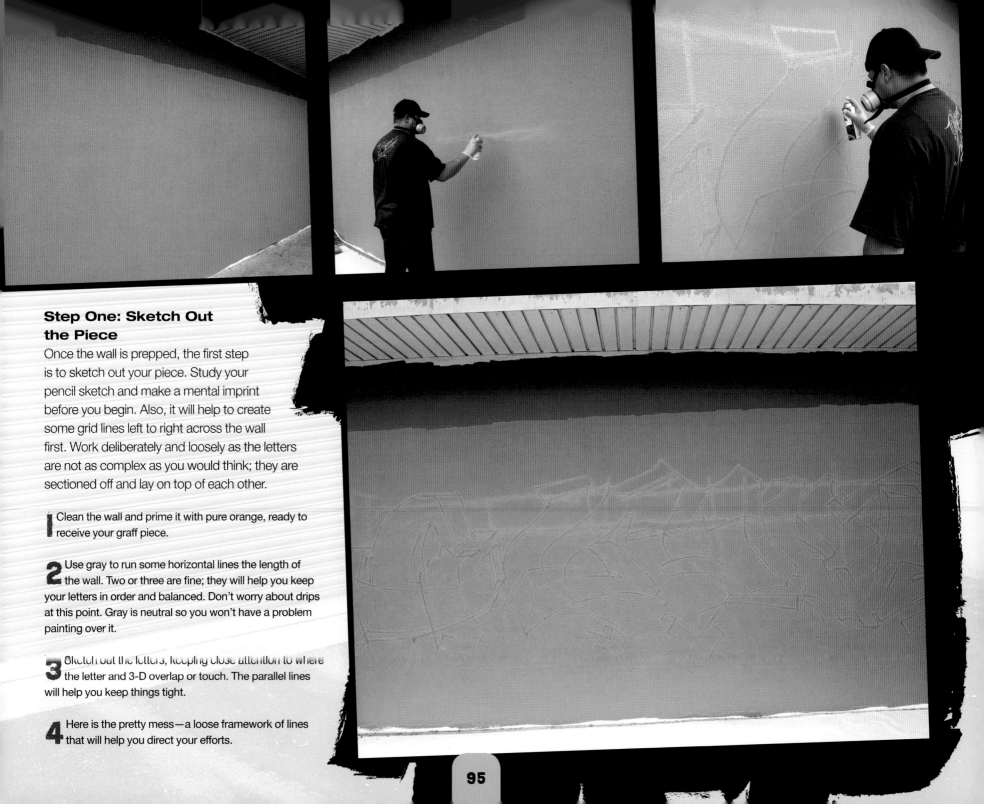

Step One: Sketch Out the Piece

Once the wall is prepped, the first step is to sketch out your piece. Study your pencil sketch and make a mental imprint before you begin. Also, it will help to create some grid lines left to right across the wall first. Work deliberately and loosely as the letters are not as complex as you would think; they are sectioned off and lay on top of each other.

1 Clean the wall and prime it with pure orange, ready to receive your graff piece.

2 Use gray to run some horizontal lines the length of the wall. Two or three are fine; they will help you keep your letters in order and balanced. Don't worry about drips at this point. Gray is neutral so you won't have a problem painting over it.

3 Sketch out the letters, keeping close attention to where the letter and 3-D overlap or touch. The parallel lines will help you keep things tight.

4 Here is the pretty mess—a loose framework of lines that will help you direct your efforts.

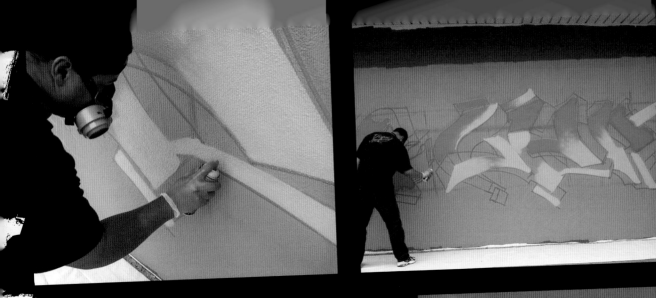

Step Two: Fill In the Letters

Get your fill-in colors together and color the spaces that represent the insides of the letters. Don't worry about going into the 3-D areas—you will fix those later. Start with two or three basic colors, then work your way up to more layers in colors, accents, cuts and extra fades.

1 Coloring within the lines, blend the blues with lavender as you go along.

2 Working with two colors, you can cover a lot of ground. The basic forms and shapes of letters should be developing.

3 When you work in the light green, add body movements to the application process. Move your arms over the piece from full arm's length at the right, then left in a broad, bold, stroking manner.

4 Sharply cut into the letterforms with true blue. Add details and focus on the edges of the letters. You want to cut out your letters to separate them from the 3-D. The blue brings out a lot of the letter shapes, and at the same time the lines and bubbles in the letter interiors add to their luster.

The Green Should Fade and Float ➜

Note the way the lime green fades and floats in the ocean of blues and purples. I land control and the types of caps you use will enable you to create this effect.

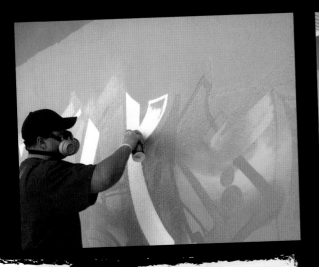

background letter face 3-D

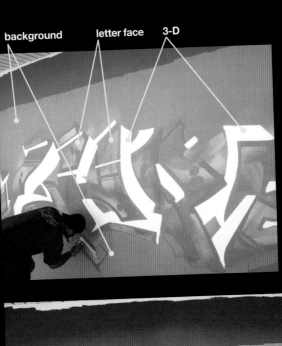

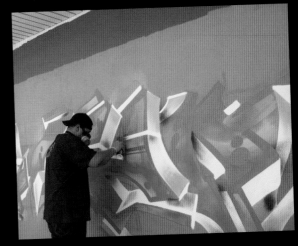

Step Three: Work the Three Dimensions

Pay special attention to the 3-D. The area will give the letters their illusion of depth and the distorted perspectives that attract the eye.

1 Lay down light blue flat at first. As you go along, this will help define and tighten the letters.

2 It's like carving a pumpkin. At the bottom of the A, separate the bits. Notice how you can see the rest of the letters now.

Finish the 3-D separation. Pay attention to the level of contrast in three elements: the background, the letter face and the 3-D.

3 Add a slightly darker shade of blue to only key areas. Look at the piece from a distance to see where you could place the light source. Add the extra shading to those areas that will promote depth.

4 Add an even darker blue to only the innermost point of the letters where there will be the most shadows. Don't worry about overspray, as that can be fixed later.

5 Use the blue from the inside of the letters to erase the overspray.

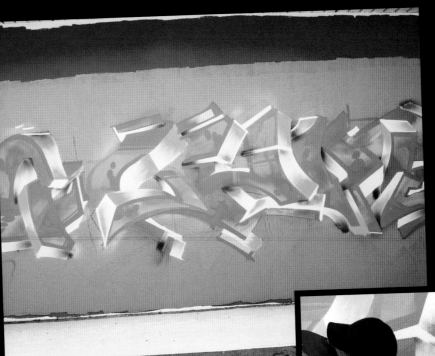

97

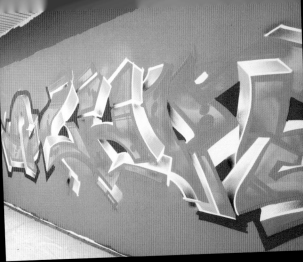

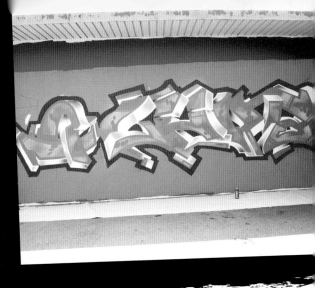

Step Four: Work the Glow

After you are done with the body and the content of the piece, turn your attention to the external parts. The first place is the glow, which is the middle ground between the letters and the background. It will tie up all the loose ends.

1 Begin from the inside spaces of the letters, then work outward. Keep your hand movements clean and crisp.

2 When you get to the edges, work clockwise, counter-clockwise, from end to end or however you see fit. Just be consistent in the direction you go.

3 Make this glow a little thicker than most, as you are going to add an outline to the work.

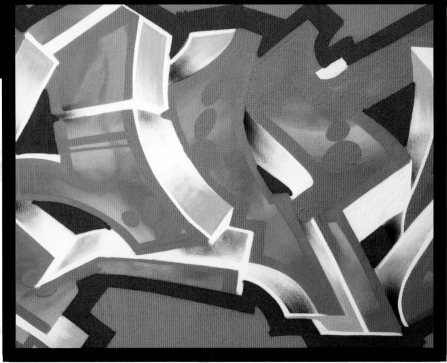

Finished Glow Close Up

Notice the nuances, where the shading plays a role in enhancing the illusion of depth. Some writers may decide to stop here, but we are going to go further.

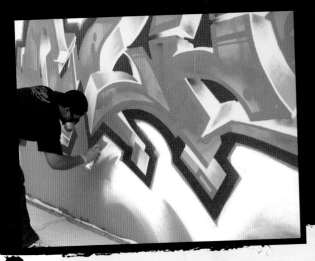

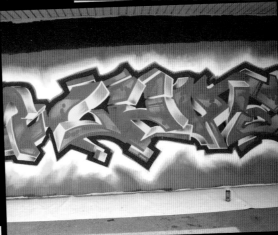

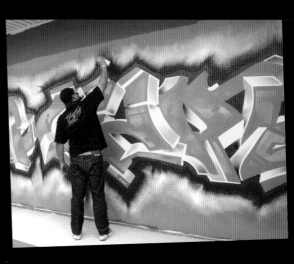

Step Five: Background and Details

The red glow isn't enough. Add to the glow and increase the bridge between it and the background orange. We use white to fill that void, and we follow with yellow (see palette on page 94).

1 Going clockwise, run white along the red glow and fade it into the orange.

2 Keep going, blending the white into the yellow, then the yellow, then the orange. The purpose is to create the illusion that the letters are glowing.

3 To further the glow effect, go back with the red with a fat cap. Blend the red outward so it goes into some of the white in some areas and, in others, into the yellow and the orange background. Step back and notice how the letters float in the red.

4 Take another step back, then add some red accents to the edges of the letters. Feather out the red in places into wisps of color.

5 Go back with the green to provide energy against the red. Use green for some of the letter interiors to add expressive lines and extra patterns.

6 From a few feet back, it's clear something else is needed. Add an orange accent as a strip along the face of the letters and down the sides and into the 3-D.

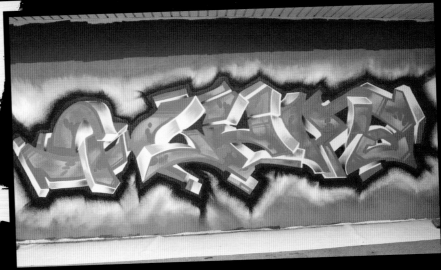

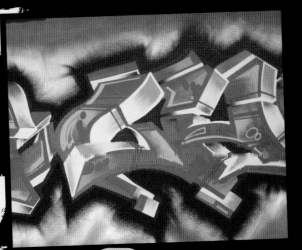

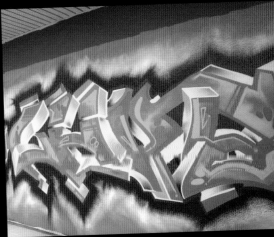

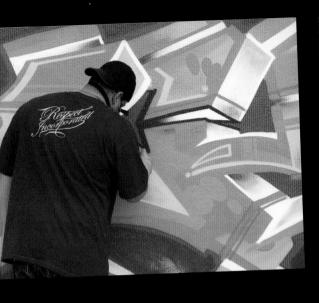
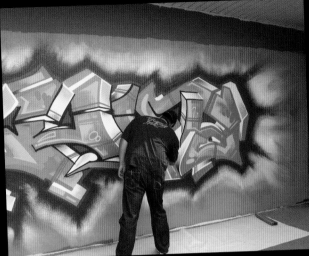
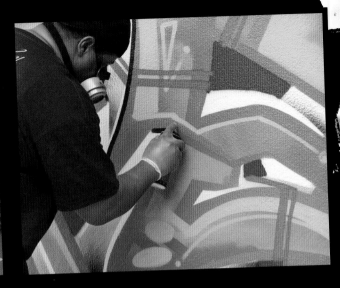

Step Six: Final Outline, Shine and Finish

Outline your piece with the dark blue. Remember to keep your lines on the exteriors of the letters and to keep the contours thicker than the lines in the letter interiors. Add shines and clouds.

1 Begin the outline and meticulously and painstakingly go through the piece. There isn't much room for error here, so if you need to take a break and rest your finger before you begin, do so.

2 It is easier to outline the areas that are at your chest level, where you don't have to extend your arms too far. Do those areas first. Pace yourself.

3 Continue into the interiors of the letters. Notice all the details and how they contribute to the illusions of 3-D and sense of depth.

1982

DONDI has his first aboveground one-man show at the Fun Gallery in New York.

Art in America publishes an article entitled "Report From New York: The Graffiti Question" featuring **FAB 5 FREDDY**, **FUTURA 2000**, Lee Quinones, Keith Haring and Jean-Michel Basquiat.

DONDI, **ZEPHYR**, and **FUTURA 2000** are flown to Santa Cruz, California, for an exhibition at UCSC where the head of the Santa Cruz transit authority offers them a bus to paint.

The video for "Buffalo Gals" by Malcolm McLaren is released and appears on MTV. Thousands of graffiti writers, particularly in Europe, acknowledge the video as their first contact with graffiti.

FUTURA 2000 teams up with the punk rock group The Clash to record the song "Overpowered by Funk."

The film *Wild Style* by Charlie Ahearn is released. The movie features the legendary New York graffiti artist LEE Quiñones as "Zoro."

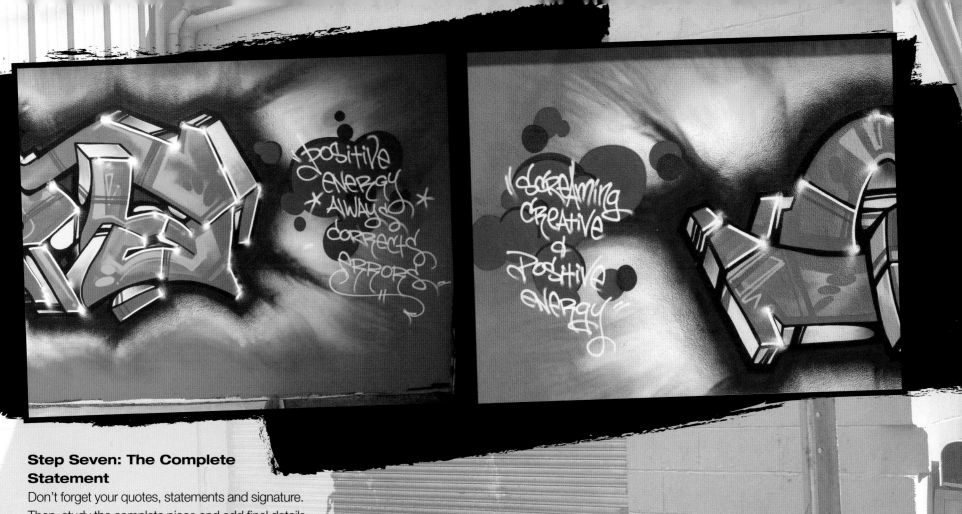

Step Seven: The Complete Statement

Don't forget your quotes, statements and signature. Then, study the complete piece and add final details and cover any mistakes. Add any little things, dots, bubbles or shines that will give your piece the proper look.

1 Positive Energy Always Corrects Errors. P.E.A.C.E. Notice how the turquoise clouds appear to float over the faded backgrounds.

2 More writing on the left side, for balance. Screaming Creative And Positive Energy. S. C. A. P. E. Same idea of having the clouds float over the fades.

WRESTLING IN THREE DIMENSIONS

Translating your graffiti into three-dimensional sculptural forms comes with its challenges. In the end, you wrestle with many complex ideas doing 3-D graff: the interplay between two- and three-dimensional space, not getting lost in all the color schemes, the juxtaposition of flat areas and 3-D. Overall it is a very intense and complex form of graff writing.

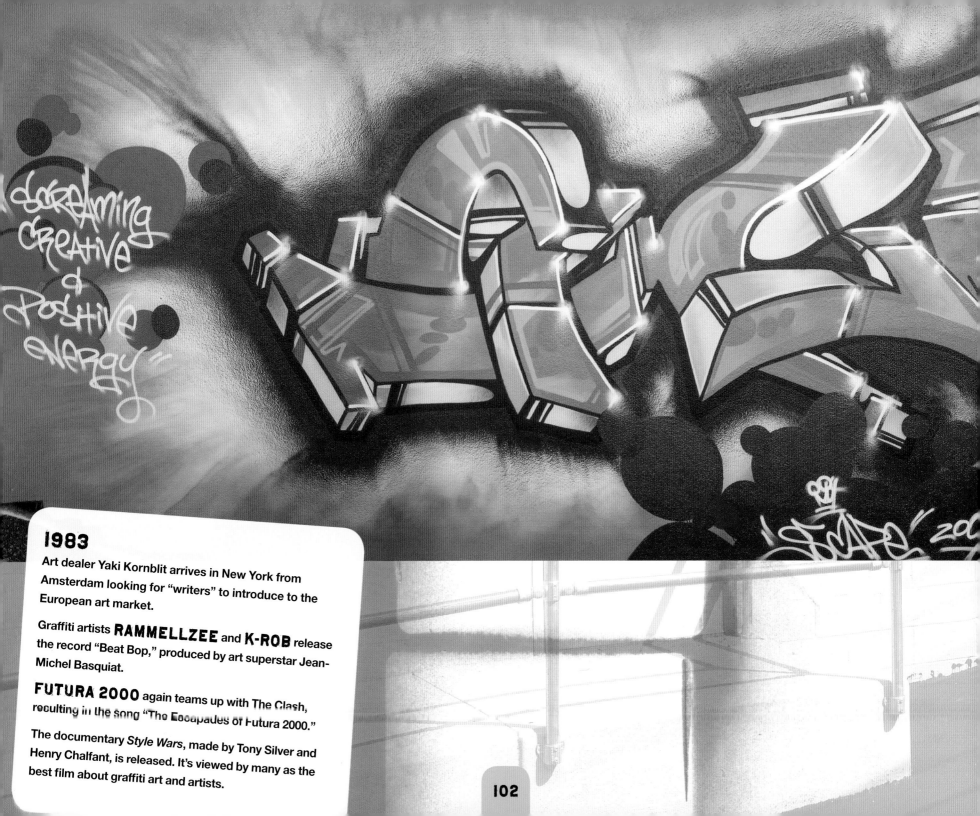

1983

Art dealer Yaki Kornblit arrives in New York from Amsterdam looking for "writers" to introduce to the European art market.

Graffiti artists **RAMMELLZEE** and **K-ROB** release the record "Beat Bop," produced by art superstar Jean-Michel Basquiat.

FUTURA 2000 again teams up with The Clash, resulting in the song "The Escapades of Futura 2000."

The documentary *Style Wars*, made by Tony Silver and Henry Chalfant, is released. It's viewed by many as the best film about graffiti art and artists.

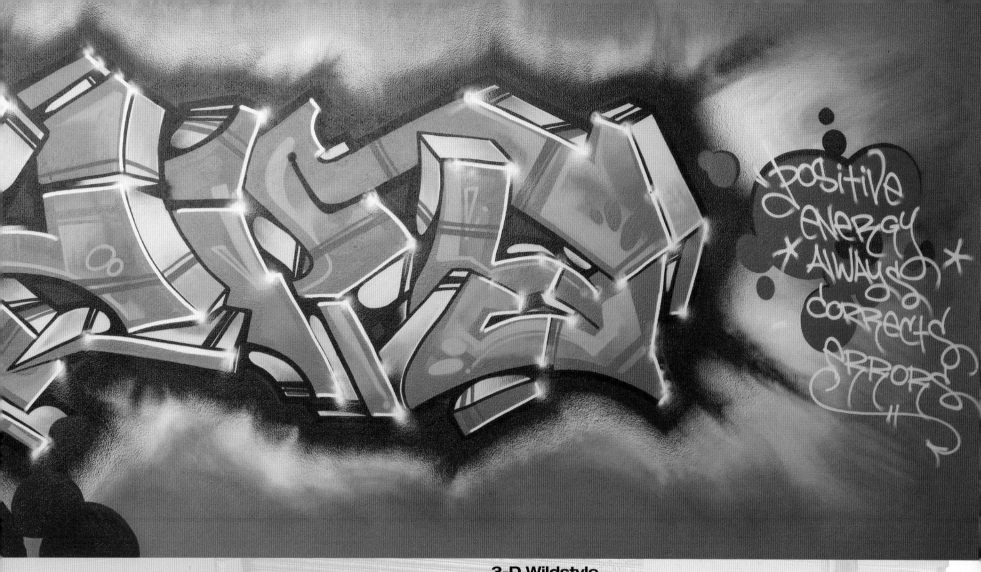

3-D Wildstyle

It's the complete statement. Notice the purple clouds in the absolute front. They actually sit in front of the letters and provide the framework for the signatures. All problems solved!

Working on Walls: Abstract

BREAKING THE RULES

In this piece, a lot of the rules from earlier graffiti work get flipped on their heads or broken altogether. The key in abstract graffiti is that it's not representational. It is about the letters, but at the same time it's not.

You use color skills to further describe certain feelings, moods and personalities. These are elements that you have already accomplished in previous pieces doing the fill-ins. Think of it as peeling back the letter outlines and letting the colors of the letters flow into the backgrounds and change the vocabulary.

In a sense, you can see more of the writer with abstract graff. It's open to interpretation, and you can discuss more about the work's vibrancy, its uniqueness, and color patterns, and the overall form and composition.

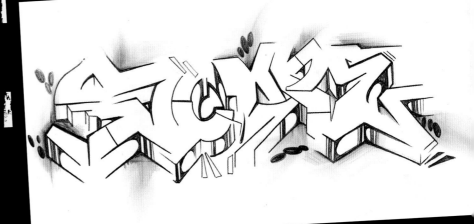

Sketch

The sketch is pretty basic, which is a good thing as it leaves the door open for improvisation—the single most important aspect of the abstract styles. It's all about capturing the moment, as though the work is a snapshot of where the artist is at the time of creating it.

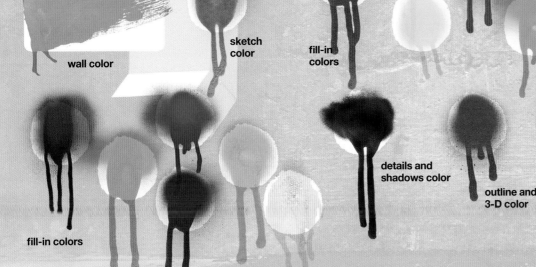

wall color

sketch color

fill-in colors

details and shadows color

outline and 3-D color

glow color

fill-in colors

Palette

This is an extensive palette. Since the wall is a shade of pink, focus on vibrant color: blues, yellows, magentas, reds and—of course—white and black as accents.

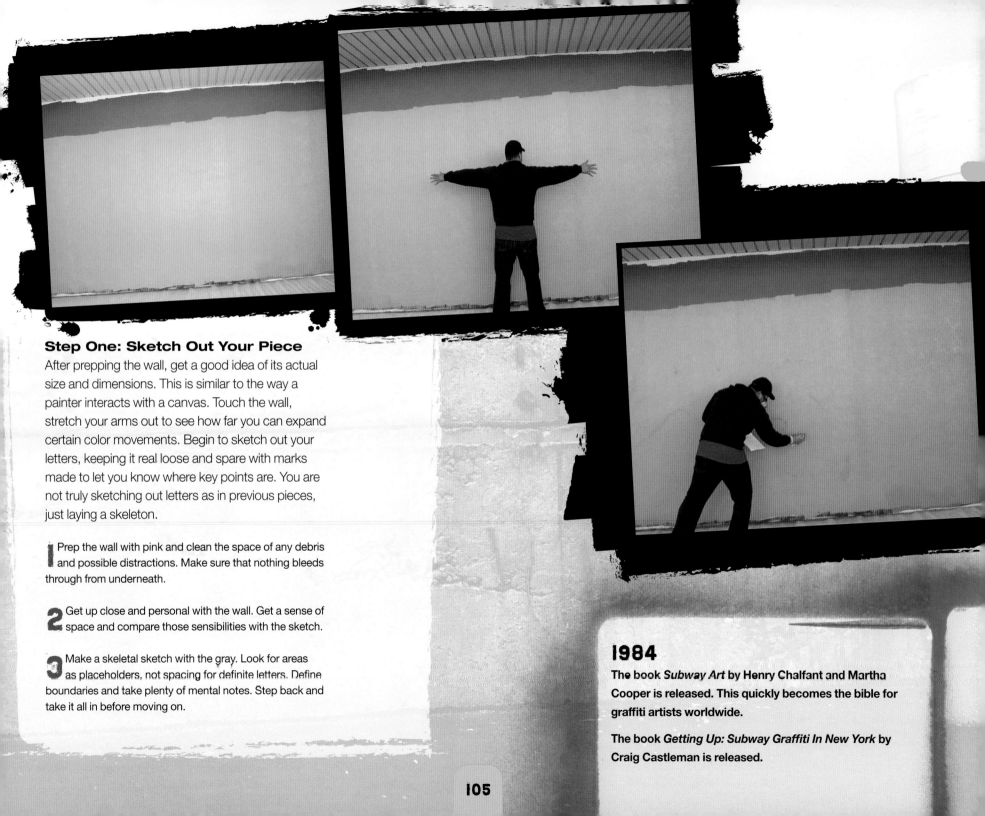

Step One: Sketch Out Your Piece

After prepping the wall, get a good idea of its actual size and dimensions. This is similar to the way a painter interacts with a canvas. Touch the wall, stretch your arms out to see how far you can expand certain color movements. Begin to sketch out your letters, keeping it real loose and spare with marks made to let you know where key points are. You are not truly sketching out letters as in previous pieces, just laying a skeleton.

1 Prep the wall with pink and clean the space of any debris and possible distractions. Make sure that nothing bleeds through from underneath.

2 Get up close and personal with the wall. Get a sense of space and compare those sensibilities with the sketch.

3 Make a skeletal sketch with the gray. Look for areas as placeholders, not spacing for definite letters. Define boundaries and take plenty of mental notes. Step back and take it all in before moving on.

1984

The book *Subway Art* by Henry Chalfant and Martha Cooper is released. This quickly becomes the bible for graffiti artists worldwide.

The book *Getting Up: Subway Graffiti In New York* by Craig Castleman is released.

Step Two: First Color Layers

Now for the first layer of fill-ins. Keep it rough as you cover the wall with color. Use your fat caps for quick covering. Two things to keep in mind:

* Cover the entire space with colors.

* Incorporate the wall color (the pink) into the piece, so leave some of it exposed.

1 After viewing from a distance and discerning the style direction, go in with pink. As you change colors, step back again.

2 Add whites, then go back in with yellow, blend it into the white. The white is blended into the pink. The white is a blender color.

3 Go in with burgundy. Because you are covering a decent amount of space, paint with your thumb, not your forefinger, to prevent fatigue.

4 After laying down a series of colors, bring in a very bright light blue to tie it all together. This will give the composition a level of claritiy. The light blue really emphasizes the up and down motion.

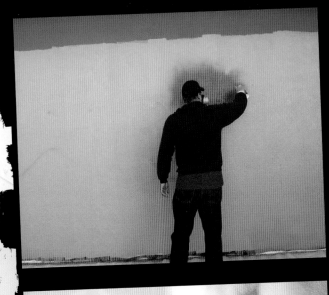

1985

"Aerosol Art" piece by **BANDO, PRIDE** and **MODE 2** is excecuted in Paris, and graffiti color patterns are pushed to new heights.

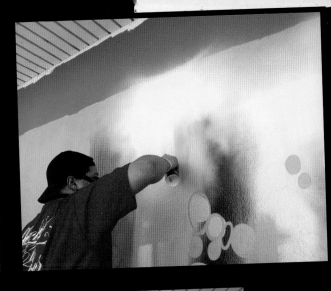

Step Three: Second Color Layers

Differentiate between the first and the second layer by changing the direction of your strokes. Begin to add details, bubbles, flourishes and various expressions. Choose colors that will pop off the wall in certain areas. In other areas do some extra blending to smooth out your color transitions.

1 Go over areas where the yellow already is with more yellow. Add bubbles and change the direction of your strokes, horizontal as well as vertical.

2 Step away to assess where the piece is. Add more details, expressive lines and orange. Promote contrast, by color, shapes, lines and blending style. Work in and around the blue. The yellow dots should clearly float over the blue.

3 Working the colors more, add vertical strokes to the edges of the composition.

4 Add horizontal strokes, then more details so the work bobs and weaves and has character. By this time, you should have used most of the colors in the palette, as well as various blends, color fades, bubbles, dots and expressive lines.

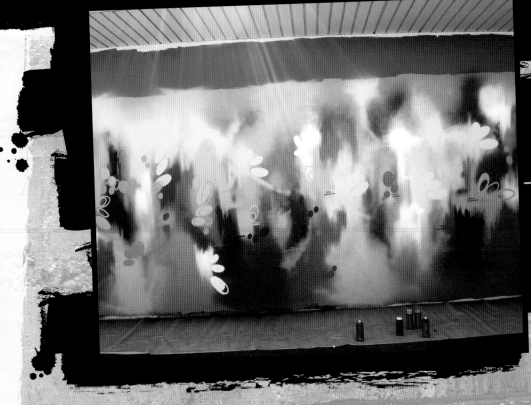

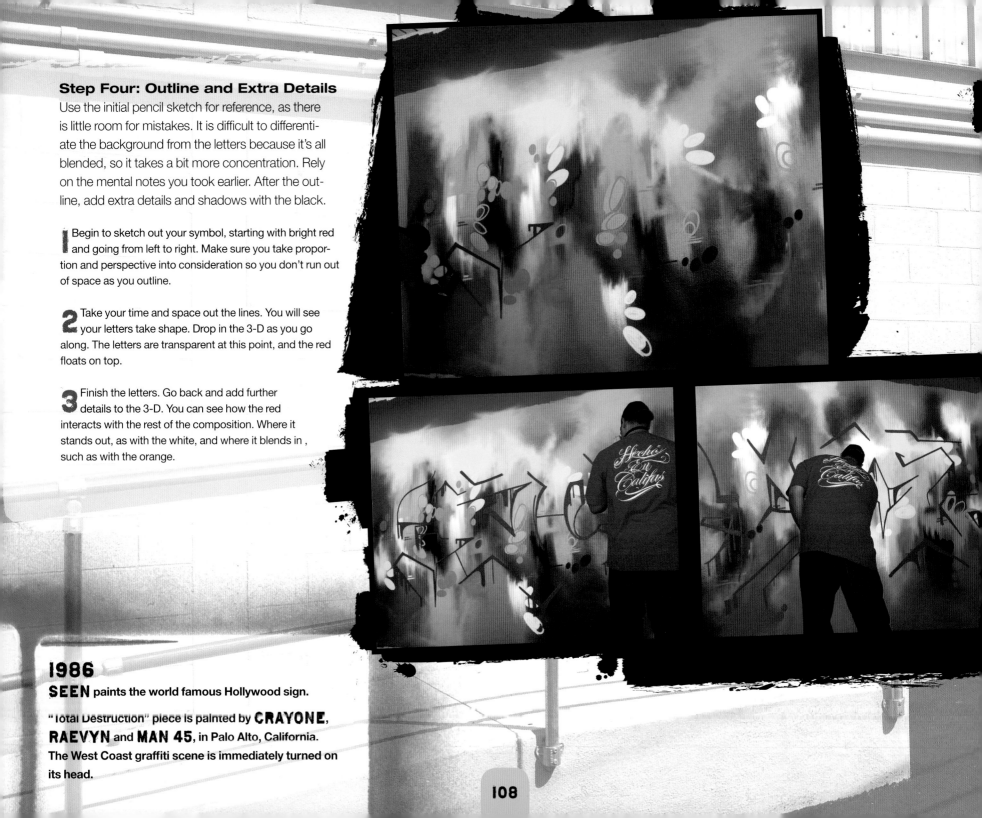

Step Four: Outline and Extra Details

Use the initial pencil sketch for reference, as there is little room for mistakes. It is difficult to differentiate the background from the letters because it's all blended, so it takes a bit more concentration. Rely on the mental notes you took earlier. After the outline, add extra details and shadows with the black.

1 Begin to sketch out your symbol, starting with bright red and going from left to right. Make sure you take proportion and perspective into consideration so you don't run out of space as you outline.

2 Take your time and space out the lines. You will see your letters take shape. Drop in the 3-D as you go along. The letters are transparent at this point, and the red floats on top.

3 Finish the letters. Go back and add further details to the 3-D. You can see how the red interacts with the rest of the composition. Where it stands out, as with the white, and where it blends in , such as with the orange.

1986

SEEN paints the world famous Hollywood sign.

"Total Destruction" piece is painted by **CRAYONE**, **RAEVYN** and **MAN 45**, in Palo Alto, California. The West Coast graffiti scene is immediately turned on its head.

108

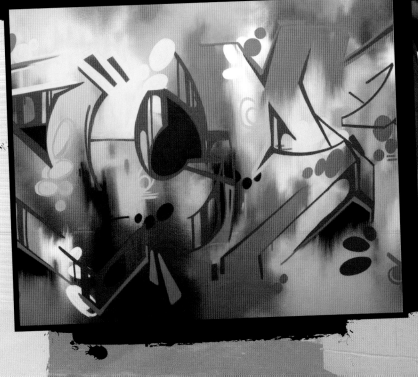

Step Five: Glow and Cutting

After the outline and details, you should see that some parts of the piece push forward and some push to the back. You can see where the letters are and where you want to leave pure color flowing. Add glow to the proper areas around the exposed edges of the letters. This will help those parts pop off the wall and will be a point of interest in the overall composition.

1 You did the outline going from left to right; now do the glow from right to left.

2 Trace the edges of the letters only in select sections. Don't go over all the outlines, only a portion. This will give the letters more snap.

3 Sometimes you have to get dirty. As you go, don't hesitate to add bits and bubbles.

4 Step back to have a clear look. The letters are visible in certain areas and completely blurred in others.

5 Add final touches to the glow and trace out final sections.

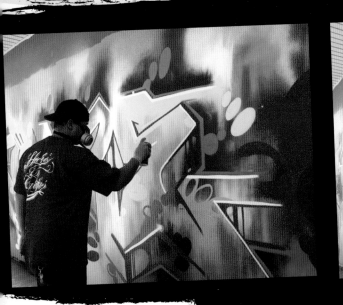

Step Six: Details, Shine and Finish

At this point, it's all about the little things. Step back and look to see where the action is. What needs your attention? Is the energy and flow correct as you can see it?

1 Go back with white and add traditional shine on the inside edges of the letters.

2 Add details and cut into the letters to correct any errors. There is plenty of visual activity going on.

3 One of the last, but most important, elements; add your tag and any quotes or statements.

1987

The book *Spraycan Art* by Henry Chalfant and James Prigoff is released.

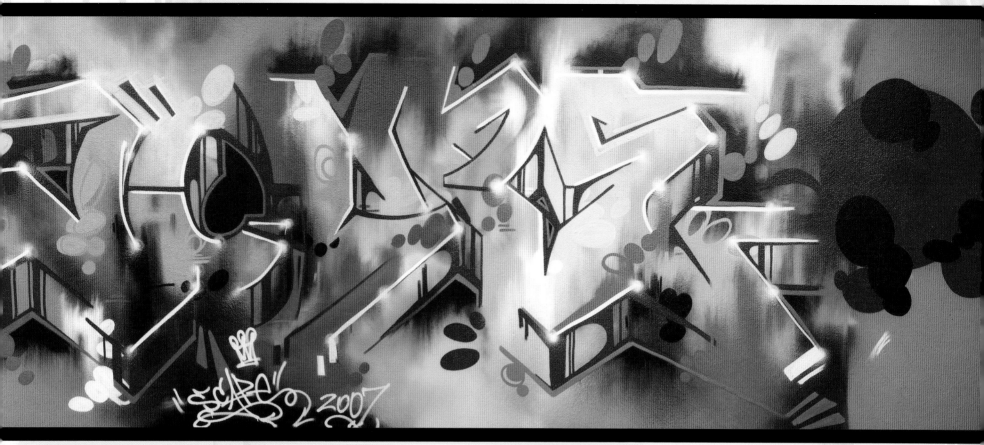

Abstract

Complete statement; take the pic. Notice the extent of the detail work and also how the black for the shadows works.

WRESTLING WITH COLOR

Graff pieces all have color as a central ingredient, and when approaching it in the abstract fashion, it has its own unique challenges. With design and spatial concerns, you will be challenged on all levels. The magic happens when you find solutions with your inventiveness.

As you search for solutions, a lot happens in your head: Combining elements of action painting, capturing the spontaneity and energy of being in the moment. And if someone is watching the frenzy of you painting, it can be a form of performance art.

In the end, it's all about trying to capture that energy, that robustness, and the creativity that your color patterns can bring.

So your letterforms take second place, but only a slight second place.

CHARACTERS

In graffiti, our characters should be funky in the sense that we are not so serious in our take on humanity, and that we want to leave plenty of room for improvisation. Don't be afraid to take certain liberties in your character's look, feel and expression. Arch the eyebrows more, enlarge the eyes and give it a "full of life" expression. My character here, he likes to observe, he likes to hang out on the street corner, and he populates my graffiti art. He's a free spirit type of guy, so I leave his hair in a loose Afro. The goal isn't to create a figure in the classical sense. We want to have a little fun and create a sense of satire with the human form.

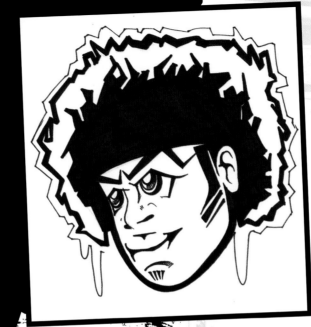

Sketch
Every masterpiece starts somewhere. Here the character is rendered in black-and-white. You are going to add from the color palette and bring him to life.

Palette
Break down the components of the character to help pick out your palette. Even the color of the wall plays a role in your color choices.

SO ... WHAT IS FUNKY?

- Funky is hot pink.
- Funky is lime green.
- Funky is purple.
- Funky is Afros and ghetto blasters.
- Funky is high contrast and exaggerated elements.
- Funky is taking the norm and pushing it over the edge.

wall color

sketch colors

fill-in colors (skin)

fill-in colors (hair)

eye and accent colors

outline colors

Sketch the Character

1 Using light blue, begin to sketch out a basic shape. Since the wall is pink, the light blue will stand out effectively, but is not too dark that you can't paint over it. Be rough when sketching out the shape of the head. Since you are just fleshing out your space, details and precision are not important. Stay fast and loose. Use the can as is. What is important here is to capture the subject in gestures, basic forms and basic values.

Do a Second Sketch

2 With a bolder color, bright yellow (yet light in value), go over the original light blue sketch, making more specific lines. In a sense, you are adding contour lines on top of the sketch. The eye can separate the yellow from the blue and redefine the figure. Tighten up the sketch, and choose which lines to keep and which areas to get rid of later. This is decision-making time, where you make bold and deliberate choices about what paint strokes to keep. Make mental notes as you go along.

Fill In the Skin

3 This is your first fill-in, just like doing letters. Keeping in mind the lines you want versus those you don't, choose a color for basic skin (see palette on page 112) and begin filling in the face. A lot of this process is covering and cutting and continually redefining the face and its shapes and features. This is a form of underpainting. As you continue, go ahead and cover up the eyes. Remember where the eyes were, though, and paint that area in a looser fashion so you can still see the sketch bleeding through the flesh color.

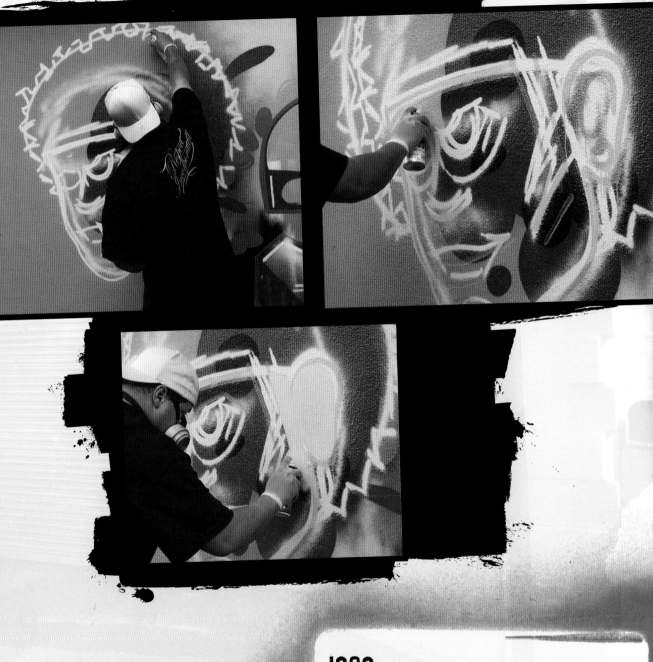

1989

The book *Subway Graffiti: An Aesthetic Study of Graffiti on the Subway System of New York City, 1970–1978* by Jack Stewart is released.

4 Fill In the Hair

Jump to the hair using four colors and a fat cap. What is important here is that you are covering space. Look at the work from a spatial perspective. Start with black and work lighter to the edge. This will promote a sense of depth. It's easier to fade a darker value over a light value.

5 Add Shading to the Face and Ears

Tighten up the face using the lightest brown. Focus on applying this shade underneath the nose area and down to the chin. You should not have any color bleeding through this area as it should have a thick covering of paint. Render the ears by spraying a cloud of black and cutting back into it with the basic brown.

6 Add Additional Graphics

To complete the face, use a darker brown. Add and cut the brown into the face, right under the hairline. Wrap and trace the brown along the edge of the hair, blending the color into the underpainting. Go back and forth between the skin brown and the darker shade, blending the two back and forth until you get the right fade.

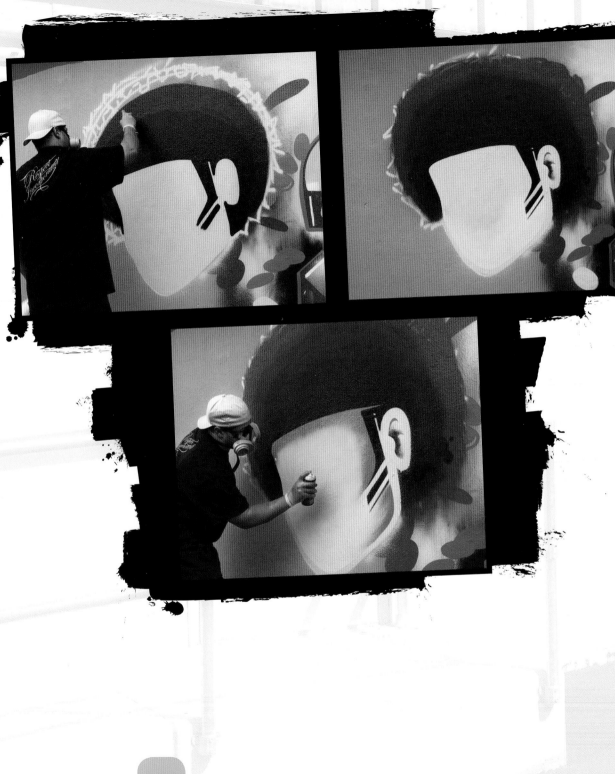

SIDEBURNS

Sideburns are bits just like in letters, and here, you definitely want to cut these into the face, using single strokes and skinny caps.

7 Add Details to the Face

The basis for this step is cutting and overpainting. For the mouth, spray a light blurred cloud of black. Then, go over the blur with the original brown skin color and cut out the shape of the lips so they are thin and crisp. Do the same with the nose. Notice how the initial black around the nose area is a simple blur, and when you cut back into it, you can create very precise and detailed lines.

8 Work the Eyes

The eyes are very important as they will convey the message and feel of the character. Use light blue first as the shade for the actual eyeball, then for the pupil. Then add eyebrows.

9 Add Details to the Hair

Remember that you have four colors for the hair. In this step chop, crop and cut the hair. Keeping the rule of working from dark to light, focus on adding sharp edges in some places and gently fading edges in others. The decision is pretty random. Keep things visually interesting while continuing all around the hair as you shape the edge of the Afro. Keep it sharp and crisp.

10 Add Glow

This where the fun comes in. What happens when you look at a pink background with brown next to it? Lime green, of course. Begin to meticulously cut out the character. This is really an outline, and to be consistent, make sure that every "section" is four strokes deep. Meaning that as you add the lime green around the hair, even in the crevices, make sure to use four strokes going parallel to get equal thickness all around. The purpose here is to make the character pop off the wall.

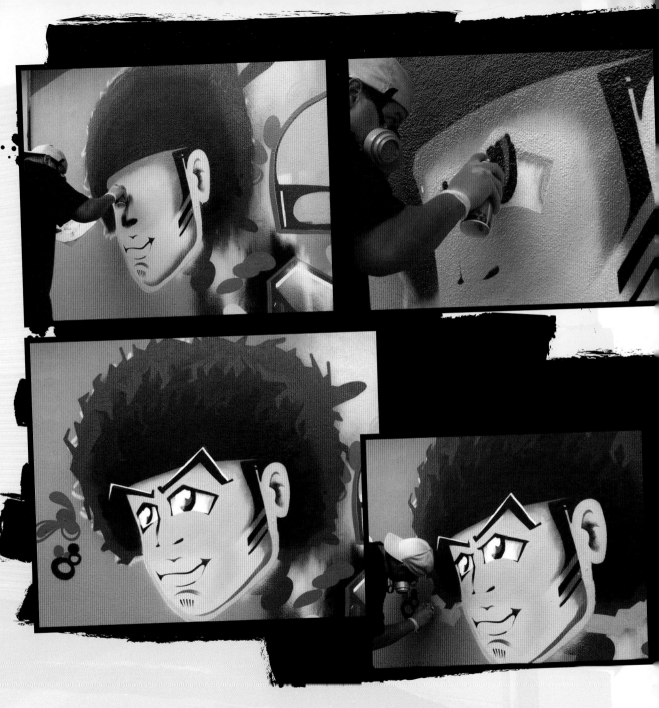

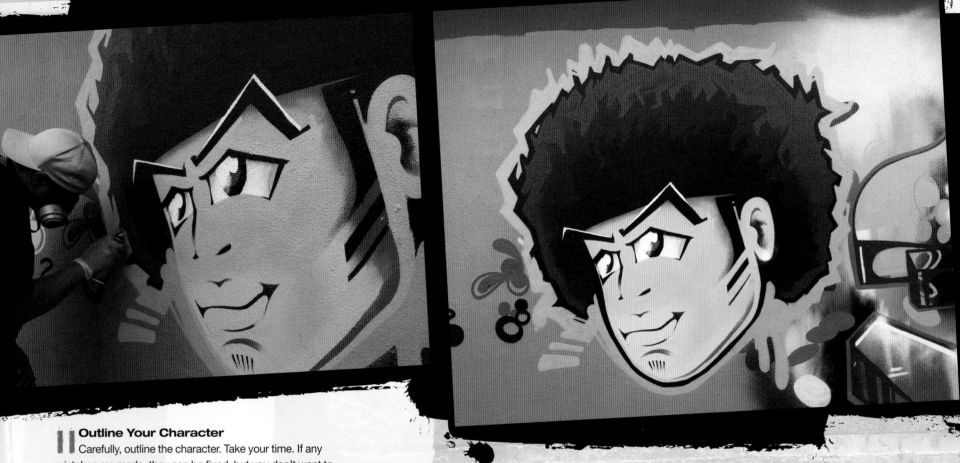

Outline Your Character

11 Carefully, outline the character. Take your time. If any mistakes are made, they can be fixed, but you don't want to rely on that option. Be aware of hand fatigue, and if you need to, a break and rest your hand before you do the final outline.

Final Details and Shine

12 Look over the character and add any little details and accents. Here, I added a small flash of white on the ear lobe. Once it's done take a picture, share with friends, applaud and clap hands. You don't know how long it's going to last. That's part of the mystery. Look how the character is connected to the piece. Scream and shout because you did it!

ALWAYS KEEPING IT REAL

There are a thousand different ways from a thousand different writers to create graffiti characters. This way I've shown you is just the way that I feel is most effective. There are as many styles as there are people on the globe, so if you want to go in a more hyper-realistic manner, more power to you.

So again, lets be clear: This isn't the end all, be all in characters, it's simply the best way I know to learn the techniques and basic concepts for the process behind the art.

Just remember to keep it funky.

As you go along, if you try doing your character and find yourself feeling frustrated., be patient. You can and will get it right.

Mastering the nature and dynamics of graffiti characters may take several years, but like a lot of things in life, you get out what you put in. So practice, practice. Your skills will improve and your work will look better and better.

SYMBOLS

Symbols can be characters, concrete representations of ideas, or concepts, and even types of abstractions or combinations of these. For this we will focus on the classic heart symbol.

Look at the physical properties of the symbols and ask yourself how you want to represent the idea. It can have deep-rooted cultural implications, or it can be constructed as a simple graphic element.

For us, the heart transcends cultures and borders. It can be a strong poetic symbol that ties together the human spiritual and emotional elements. It can even have an intellectual aspect to it, as the heart can be seen as being a part of the soul and the mind.

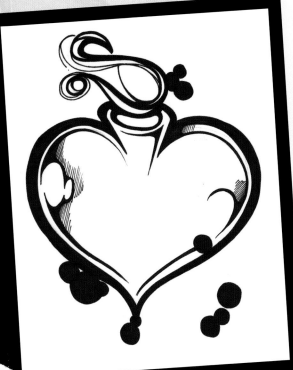

Sketch
This symbol is rendered in black and white. Add a few black dots and graphics.

wall color

sketch colors

fill-in colors

glows and accents colors

flame colors

Palette
The wall color determines what colors will work for accents, graphics, glows etc. This heart will be white.

1994
Graffiti art goes online officially. Art Crimes, the first graffiti site on the Internet at www.graffiti.org, is launched.

Montana Colors (Spanish version) debuts their specially manufactured spray paint for graffiti artists.

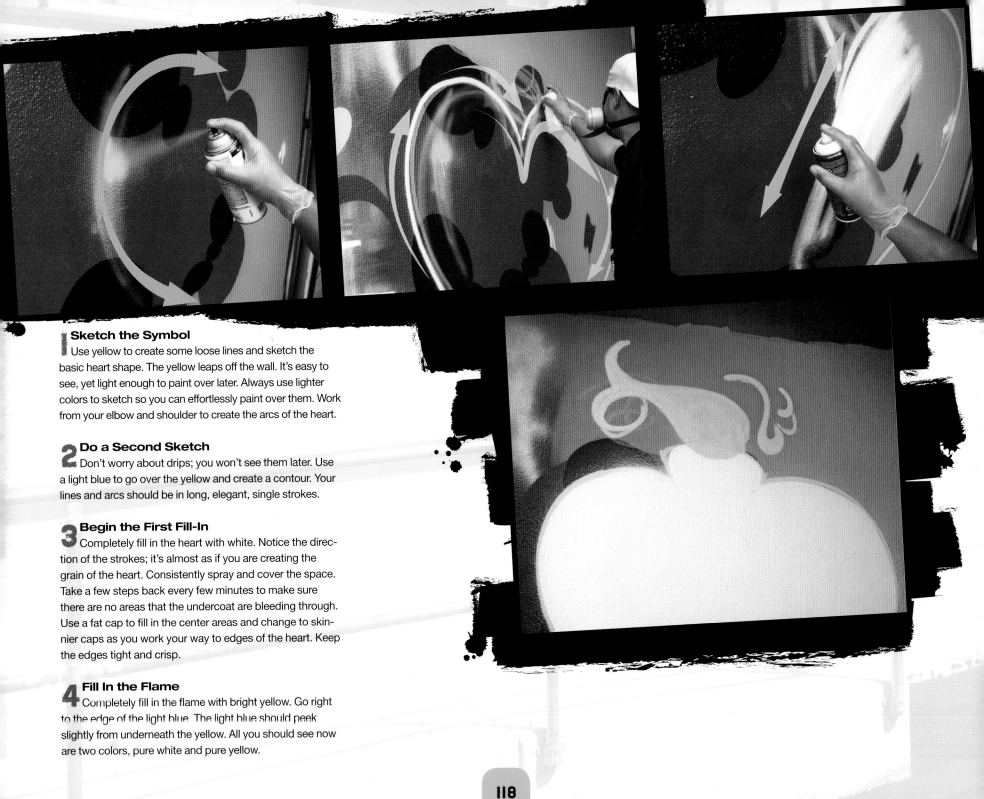

Sketch the Symbol
1 Use yellow to create some loose lines and sketch the basic heart shape. The yellow leaps off the wall. It's easy to see, yet light enough to paint over later. Always use lighter colors to sketch so you can effortlessly paint over them. Work from your elbow and shoulder to create the arcs of the heart.

Do a Second Sketch
2 Don't worry about drips; you won't see them later. Use a light blue to go over the yellow and create a contour. Your lines and arcs should be in long, elegant, single strokes.

Begin the First Fill-In
3 Completely fill in the heart with white. Notice the direction of the strokes; it's almost as if you are creating the grain of the heart. Consistently spray and cover the space. Take a few steps back every few minutes to make sure there are no areas that the undercoat are bleeding through. Use a fat cap to fill in the center areas and change to skinnier caps as you work your way to edges of the heart. Keep the edges tight and crisp.

Fill In the Flame
4 Completely fill in the flame with bright yellow. Go right to the edge of the light blue. The light blue should peek slightly from underneath the yellow. All you should see now are two colors, pure white and pure yellow.

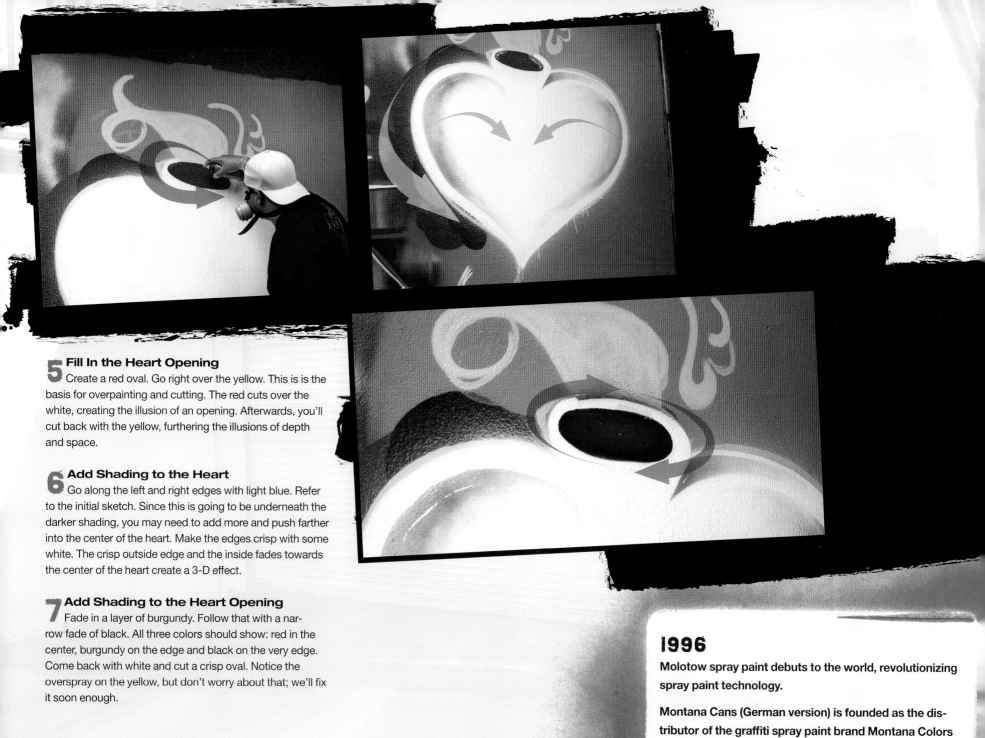

5 Fill In the Heart Opening

Create a red oval. Go right over the yellow. This is is the basis for overpainting and cutting. The red cuts over the white, creating the illusion of an opening. Afterwards, you'll cut back with the yellow, furthering the illusions of depth and space.

6 Add Shading to the Heart

Go along the left and right edges with light blue. Refer to the initial sketch. Since this is going to be underneath the darker shading, you may need to add more and push farther into the center of the heart. Make the edges crisp with some white. The crisp outside edge and the inside fades towards the center of the heart create a 3-D effect.

7 Add Shading to the Heart Opening

Fade in a layer of burgundy. Follow that with a narrow fade of black. All three colors should show: red in the center, burgundy on the edge and black on the very edge. Come back with white and cut a crisp oval. Notice the overspray on the yellow, but don't worry about that; we'll fix it soon enough.

1996

Molotow spray paint debuts to the world, revolutionizing spray paint technology.

Montana Cans (German version) is founded as the distributor of the graffiti spray paint brand Montana Colors for Germany, focusing on the needs of the graffiti artist.

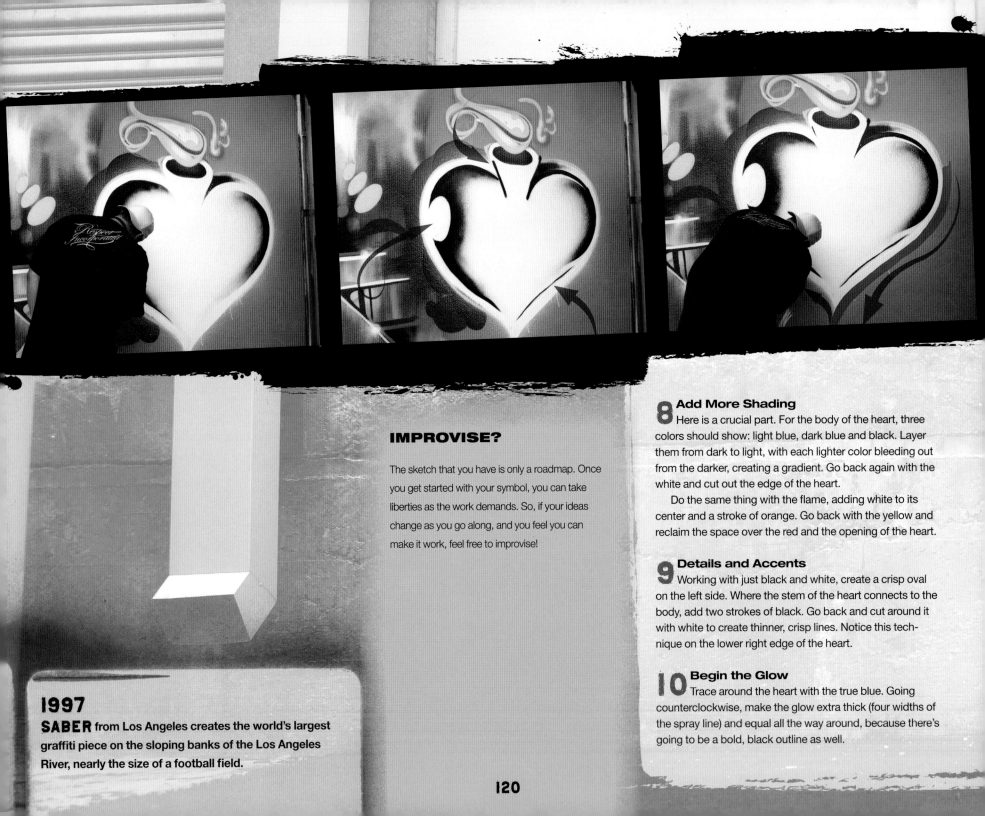

IMPROVISE?

The sketch that you have is only a roadmap. Once you get started with your symbol, you can take liberties as the work demands. So, if your ideas change as you go along, and you feel you can make it work, feel free to improvise!

8 Add More Shading

Here is a crucial part. For the body of the heart, three colors should show: light blue, dark blue and black. Layer them from dark to light, with each lighter color bleeding out from the darker, creating a gradient. Go back again with the white and cut out the edge of the heart.

Do the same thing with the flame, adding white to its center and a stroke of orange. Go back with the yellow and reclaim the space over the red and the opening of the heart.

9 Details and Accents

Working with just black and white, create a crisp oval on the left side. Where the stem of the heart connects to the body, add two strokes of black. Go back and cut around it with white to create thinner, crisp lines. Notice this technique on the lower right edge of the heart.

10 Begin the Glow

Trace around the heart with the true blue. Going counterclockwise, make the glow extra thick (four widths of the spray line) and equal all the way around, because there's going to be a bold, black outline as well.

1997

SABER from Los Angeles creates the world's largest graffiti piece on the sloping banks of the Los Angeles River, nearly the size of a football field.

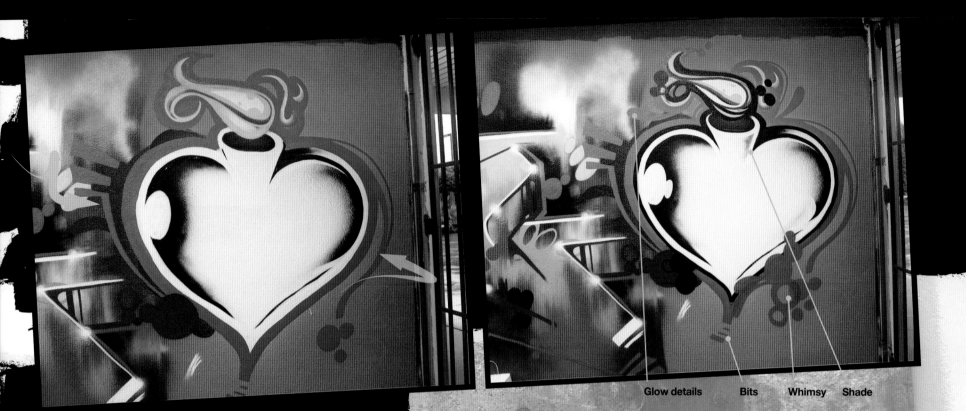

Glow details Bits Whimsy Shade

11 Add Flourishes

Continuing with the blue, add flourishes—bits and elegant lines. This is all intuitive work since this is not part of the original sketch. The flourishes accomplish two things: They give the symbol its own identity, and they help incorporate the symbol into the rest of the work.

12 Final Outline and Details

Add the final thick, black outline, black dots and whimsical orange shapes. Then add an extra white oval to the shine on the left and bits of blue … extra details all around.

I also added a small fade to the stem to enhance its conical shape.

MAKE YOUR MARK

Symbols are a powerful tool for communication. They are made even more powerful through their use in graffiti. They can instill beliefs and shape, or even shift, the attitudes of social structures. Symbols help us make sense of the world and, in a way, help us make sense of ourselves.

What about your symbol? Is it something that can be emblazoned on a T-shirt, a sticker or any other surface? Ideally, it should be easily recognizable. Over time, it could even become a mark that viewers recognize as yours, synonymous with your tag. And that right there speaks volumes.

GRAFFITI ART IN THE COMMUNITY AND IN THE WORLD

Graffiti artists may be true folk artists. Like visual poets, they sling their paints like verbs and nouns, creating stunning statements all the way through. They tell their true tales from the heart and soul, redefining not only themselves, but their communities, embedding their statements into the collective memories of the people. A visual narrative directly connects the streetcorner to the spirit, bypassing the definitions of art presented by art galleries and museums. As if put into a blender, the ingredients mix and the letters become pictures, merged with the personality of the writer. The colors take shape, statements are made, dreams are made manifest, and truth is made real. That is graffiti art. Poured out like water.

Prophets With Spray Cans

Staring at the buildings; they are bare. Staring at the spaces; they are boring. All the while the artist's energy and blood is seething with stories to tell. Almost with a sense of prophecy, the artist looks at the emptiness and can see what he will make happen in the future. From nothing, the graff writer makes something.

Graff writers connect to where they are from and to their community in a way that some find difficult to understand. In all parts of the world, graffiti writers are visual recorders, illustrating the concerns and issues of their communities in tangible ways that the usual news channels refuse to convey. That is, until after the fact.

1998

Norwegian Post Office celebrates the invention of the spray can with issuing a postage stamp.

Dondi White passes away from AIDS on October 2. Graffiti styles take one step backwards.

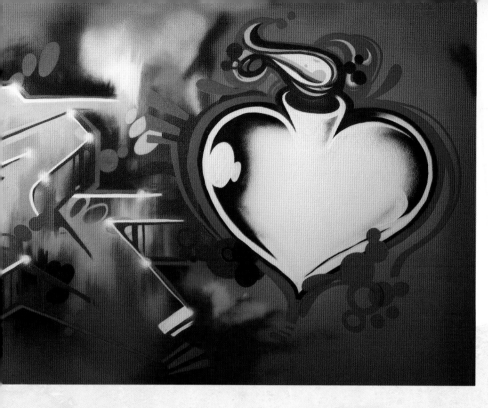

Style Medicine for a Sick World

All the styles, parts and pieces that we discussed in this book have been employed and are used all over the world in pop culture, advertising, fashion, animation, skateboarding, digital design and more. Because graff allows for three key things.

* **Innovation:** Every good style inspires an even better style. It's the old maxim that good art should inspire greater art. And graffiti has inspired and influenced all manners of visual information.

* **Cultural re-education:** Why do people need art? Why do we want to create it, and why do we like to view it? On both sides of the question—whether an arts educator or graffiti policy developer or even the writer themselves—all parties receive an adjustment in their perspective.

* **Exposure to the arts.** Wildstyle changes with each individual artist's interpretation of the style, but all of it relies on basic artistic principles. The end product exposes both the artist and the audience to all sorts of new artistic information, and a new dialogue can begin.

As for the future of graffiti, that is in your hands—not the hands of museums and gallery owners. All graff writers that came before you laid down the bricks of the road, and it's up to you to continue. Graffiti will move along as the whole of humanity moves along. Things will evolve, and new styles will meet up with new technologies to express how we feel. A new aesthetic will always come about. So it went from caves to rocks, to walls, to trains, back to walls, now to your computer and cell phones … What's next?

Ask yourself.

How Do You Communicate?

* How do you tell the world that you exist?

* How do you take a truth and post it for your community to see?

* How do you take a letter and turn it into a picture?

* How do you take an expression and twist it and code it, so only a handful of people can understand it?

* How can you make your world a better place?

* And who controls those avenues? Do you control it?

Think for yourself and leave your mark on society.

2001

The book on the life of graffiti writer **DONDI** *Dondi White Style Master General: The Life of Graffiti Artist Dondi White*, by Andrew Witten and Michael White, is published by Regan Books.

MARE 139 designs the BET Lifetime Achievement Award.

GLOSSARY

ALL CITY Can refer to a crew or a writer. Means to go all over the city in the effort to cover the most with the best.

BACK IN THE DAY Means old school, or when the writer first started his career.

BACKGROUND The colors or designs that sit behind the letters. Originally done to discern the letter from the miscellaneous tags and whatever lies beneath the artwork to make it stand out.

BACK-TO-BACK Graffiti art that is connected from end to end all the way across a wall, or a train, or even a fence.

BATTLE When two writers or two crews go against each other in a challenge to see who is best. It can be a skills battle or a getting-up battle, or a mix of both. Sometimes, even a neutral judge, a group of peers, or an outside crew or writer decides who wins.

BITE To copy another writer's style and then claim it as your own. Everyone borrows styles, from all sorts of visual material and from each other, especially when starting out, but few good veteran writers bite.

BLACKBOOK A graffiti artist sketchbook, sometimes called a "piece book." It is often used to collect other writer's tags, and future plans for bombing and piecing.

BLOCKBUSTER Huge block letters, big and square, designed to take up as much space as possible. Larger than a throw up and used many times to cover another writer's work.

BOMB The action of doing graffiti. Putting up your tag, or doing throw ups, or piecing in a certain area.

BOMBING To go out and write graffiti art, e.g. "Jimmy is bombing that wall."

BUBBLE LETTER A style of graffiti letters, balloonish and rounded in shape, easily rendered and relatively basic. Used primarily for throw ups.

BUFF To remove graffiti from public spaces with chemicals and other materials, or to paint over graff on walls with a flat color.

BURN To beat any and all competition with your style. Also, a descriptive term, as "that piece burns."

BURNER A full-fledged piece. Large full blown, with multiple color fills, background, characters, wildstyle letters, etc. Heavily detailed.

CAPS The interchangeable spray can nozzles fitted to the can to modify the width of the spray. Both fat and skinny, and countless types in between. Names such as fat caps or skinny caps. Also referred to as tips.

CHARACTER An illustrated figure added to a piece to add emphasis or push the idea of the burner forward. Sometimes the character takes the place of a letter in the piece.

CLOUD A background element used frequently in pieces. Tightly rendered, they can appear as tight bubbles, or loosely rendered as faded areas of color.

COMPUTER STYLE A particular type of wildstyle that looks very angular, and has "digital" qualities, or resembles the renderings the one would define as being "technological" or "robotic" in nature.

CRAZY Wild and imaginative, going to the extreme. "That is a crazy style!"

CREW A loosely knit band of graffiti writers, a clique. Crews are not gangs, although they are sometimes confused as such. Many times writers are members of more than one crew at any particular time.

2006

Under license from Marc Ecko, Atari releases the video game "Marc Ecko's Getting Up: Contents Under Pressure." Graffiti art and culture invade the medium of gaming, and a new frontier is opened.

CUTTING LINES A painting technique used on characters and the fills of letters to create sharp edges and very thin lines, thinner than skinny caps.

DIS Short for the word *disrespect*. To insult.

DEF Means really, really, good. "That style is def!"

DOPE Another term used to indicate the level of cool. "That is sooo dope."

DOWN To indicate whom you are connected to or with. To be a part of the group, or OK with the idea. "Oh, we are so down with them." Or, "I'm down with that."

END-TO-END When a piece covers a surface, whether that is a train, a bus or a wall, from one end to the other with no breaks.

FADE To blend or mix colors.

FAME The ultimate prize for a writer. It's what a writer gets when he is consistently getting up. Fame is primarily focused within the graffiti subculture, but many times an artist breaks the mold and gets mainstream recognition.

FILL sometimes called fill-ins. The color patterns inside of the letters of a piece or throwups.

FLICKS Pictures; prints of photos of graffiti.

FRESH Something that is equally new, cool and good.

FRONT As in "to front," to hassle someone, or to want to fight someone. Also means when an individual keeps up a mask, or a false exterior. "Oh, he got his front up." Also can mean when someone is trying to impress another he doesn't like with things he can't afford. "Hey, he's trying to front on you with that fake stuff."

GETTING UP To hit up a surface, any surface with any form of graffiti, whether that is a tag or a full-blown burner.

GOING OVER To paint over another's graffiti with your own, with the idea that yours is better. There is a hierarchy of sorts … a throw up can go over a tag, a piece over a throw up, and a burner over a piece. It's unacceptable for a throw up to go over a burner; that is disrespectful.

HIT UP The action of tagging up a surface with paint or inks.

HOMEMADE A handcrafted marker made from old deodorant containers or baby food bottles, stuffed with felt chalkboard erasers and filled with permanent ink.

KILL The action of getting up in a major way, to bomb intensely in a certain area.

KING A writer who has mastered the art form. Also means the writer who has the best with the most. In some cases, a king can be only in certain areas, e.g., king of styles, king of throw ups, king of a certain line, etc.

MAD A quantitative comment, having an obscene amount. "SCAPE has mad styles."

MAGNUM A very popular type of fat marker.

MEAN STREAK A popular opaque and water-proof paint stick.

MURAL Large-scale type of piecing, done on a wall, top-to-bottom and end-to-end. Sometimes called a production. Encompasses all the elements of a burner, only bigger.

OLD SCHOOL A general term used to refer to an earlier time of writing. Generally refers to the '70s and '80s, but can also be a decade reference, meaning a writer in 2009 may refer to the '90s as old school, and a writer from the '90s may refer to the '80s as such and so on.

OUTLINE Sometimes called a sketch, the drawing done in a piece book prior to doing an actual piece; Also the final outline done around a piece to complete it.

PIECE Short for *masterpiece*, requiring more time than a throw up, a piece incorporates 3-D effects,

many style elements, color patterns and the like. Characters and symbols are also used. Also, the action of going out to paint graffiti, but not tagging. "to piece."

PIECE BOOK A graffiti writer's sketchbook, where his sketches, outlines and ideas are kept. Also called a blackbook.

PIECER A writer that has abandoned tagging and strictly goes out to piece.

PROPS Getting respect.

RACK To steal your art supplies, markers and paint.

RUN The length of time a graffiti piece remains up before being removed.

SEMI-WILDSTYLE A style of letters with more elements and flourishes than normal lettering, but not as illegible as wildstyle.

SICK Very, very good, both at technique and style. "Johnny has sick style."

SLASH To put a tag or a blemish, line or mark out over someone's piece. Considered a form of disrespect.

STICKERS Considered a form of tagging. Most commonly saying, "hello my name is," but can be any type of illustration placed on a sticker and plastered all over the public sphere.

TAG A writer's signature, his "nom de plume," for example, **SCAPE** is my tag. The most basic form of graffiti, it is essentially the writer's logo. Also the action of signing your name as in "to tag."

TAGGER As opposed to a writer a tagger only tags and never pieces. A polar opposite to a piecer and in many cases they do not co-exist.

3-D An added dimension of style, a three-dimensional style added for a realistic effect to letters.

THROW UP Your name in quickly drawn bubble letters with one or two colors and an outline. Done very quickly, used to cover space, grab attention and show that you were there.

TOP-TO-BOTTOM Originally meaning a piece that covered a train car from the top to the bottom. These days it can also pertain to a wall or a building, many times becoming synonymous with a mural.

TOY When a writer first starts out, he is considered a toy. But as a writer continues his path, it becomes a derogatory term for an unskilled or weak artist.

ULTRA-WIDE Any marker that is about 1½" (38mm) in width, also is refillable.

UP When a writer is very active and his work appears regularly in a lot of areas.

WACK Refers to an ugly style; when something is substandard or looks weak.

WILDSTYLE An elevated style of letters, with lots of arrows, connections, and complex color patterns. Difficult to master, and entirely unreadable.

WHOLE CAR A collaborative effort where a whole train car is covered from top-to-bottom and end-to-end.

WHOLE TRAIN Like a whole car, but covering an entire train. A collaborative effort.

WRITER Someone who practices the art of graffiti.

INDEX

2007

As a result of the global phenomenon of graff art, Montana Cans introduces the first ever scholarship program dedicated to street artists.

Scape Martinez writes this book.